Michelangelo
Masterpieces of Art

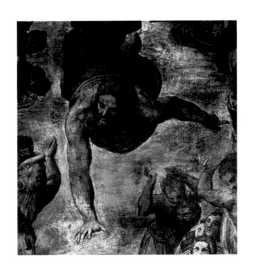

Publisher and Creative Director: Nick Wells
Project Editor and Picture Research: Laura Bulbeck
Art Director: Mike Spender
Digital Design and Production: Chris Herbert
Special thanks to: Christine Dube, Frances Bodiam and Helen Crust

Publisher's Note: Michelangelo's original masterpieces date back to the sixteenth century. The images featured throughout this book are therefore seen in differing states, spanning various decades and restorations. They represent the inherent nature of enduring art – it is not static, but made ever richer by time.

FLAME TREE PUBLISHING
Crabtree Hall, Crabtree Lane
Fulham, London SW6 6TY
United Kingdom

www.flametreepublishing.com

First published 2015

15 17 19 18 16
1 3 5 7 9 10 8 6 4 2

© 2015 Flame Tree Publishing Ltd

Michelangelo: Artist & Sculptor images: © **Bridgeman Images** and the following: Palazzo Vecchio (Palazzo della Signoria) Florence, Italy: *The Genius of Victory* 7; De Agostini Picture Library/G. Dagli Orti: *Tomb of Giuliano de Medici, c.* 1526–34: 11; Museo Nazionale del Bargello, Florence, Italy: *The Drunkenness of Bacchus* 1496–97: 17; British Museum, London, UK: *Sketch for The Last Judgement* 23; New Sacristy, San Lorenzo, Florence, Italy *Dawn*, detail from the *Tomb of Lorenzo de Medici* 25; De Agostini Picture Library: *Rondanini Pieta,* 1552–64: 27; © **Getty Images** and: Mondadori Portfolio: View of the Sistine Chapel 6; Barisotti/Mondadori Portfolio: *Madonna of the Stairs,* 1491: 8; Sergio Anelli/Electa/Mondadori Portfolio: *Crouching Boy,* 1530–34: 9; The Print Collector: *Studies for the Figure of the Cross-bearer in The Last Judgement,* 1913: 12; Alinari Archives: *Drawing of Pope Julius II Tomb* 18; © **Shutterstock.com** and: javi_indy: *Pieta* at St Peter's, Vatican, 1498–99: 14; abxyz: Statue of David 16; S-F: St Peter's Basilica dome 26; **Wikimedia Commons** and: Sailko: *Battle of the Centaurs* 10; Public domain: *Study of an Ignudo* 13; Jörg Bittner Unna: Statue of David 15, *Moses*, detail from *Tomb of Julius II* 24; Jean-Pol GRANDMONT: *Madonna of Bruges* 19.

All other images are © **akg-images**: 38; and: Erich Lessing 57, 60; © **Artothek** and: Joseph S. Martin 42; Domingie & Rabatti – La Collection 106; Public domain/**Wikimedia Commons**: 33, 47, 55, 62, 64, 71, 113, 114, 123; © **Bridgeman Images** and: Vatican Museums and Galleries, Vatican City 35, 36, 39, 41, 46, 61, 68, 69, 80; Vatican Museums and Galleries, Vatican City/Artothek 45; British Museum, London, UK 52, 93, 102, 108, 115, 117, 125; Metropolitan Museum of Art, New York, USA 73; Cappella Paolina, Vatican, Vatican City 95; De Agostini Picture Library/ A. Dagli Orti 96; National Gallery, London, UK 101, 103; Louvre, Paris, France 104; Galleria degli Uffizi, Florence, Italy 105; Ashmolean Museum, University of Oxford, UK 107, 110; Private Collection 109; Casa Buonarroti, Florence, Italy 111; J. Paul Getty Museum, Los Angeles, USA 116; Royal Collection Trust © Her Majesty Queen Elizabeth II, 2014 118, 120; Samuel Courtauld Trust, The Courtauld Gallery, London, UK 121; Isabella Stewart Gardner Museum, Boston, MA, USA 122; © **Getty Images** and: Massimo Pizzotti 34, 40; Mondadori Portfolio 50, 54, 58, 59, 67, 70, 72, 76, 81, 83, 85, 88, 89, 90, 91, 92; Fine Art Images/Heritage Images 66; Universal History Archive 86; Hulton Fine Art Collection 97; DeAgostini 112; DEA PICTURE LIBRARY 124; © 2015. Photo **Scala**, Florence: 51, 53, 56, 74, 75, 77, 94; © david5962/ **Shutterstock.com**: 44; © **Superstock**: 84 and: Exotica 63; © **Topfoto** and: E&E Images/HIP 82, Fine Art Images/HIP 100.

ISBN: 978-1-78361-361-8

Printed in China

Michelangelo
Masterpieces of Art

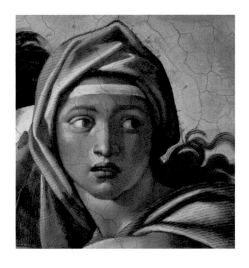

Joseph Simas

FLAME TREE
PUBLISHING

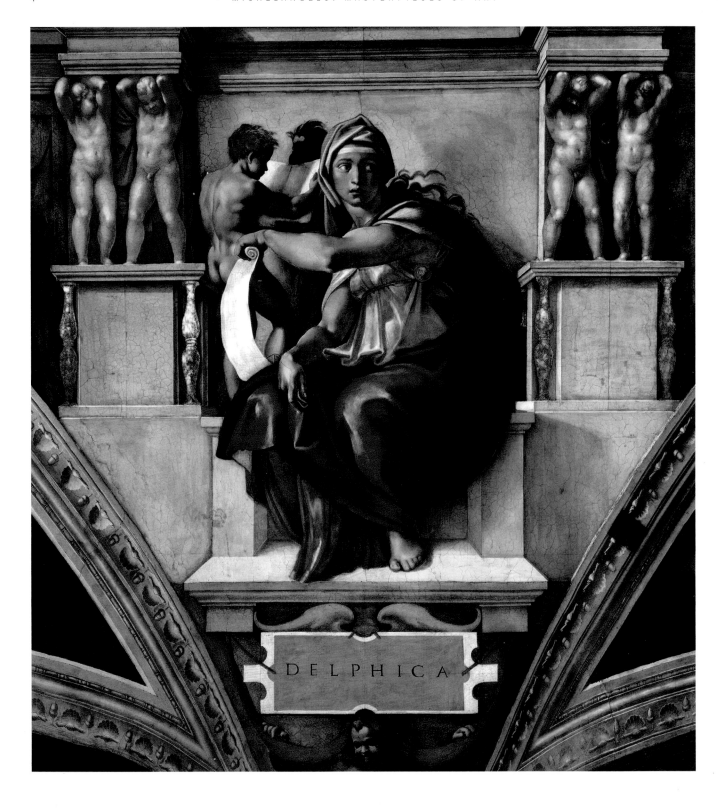

DELPHICA

Contents

Michelangelo: Artist & Sculptor

The task of introducing a man – one revered by the greatest and most powerful decision-makers and artists of his times as divine, and one of the few who could bear the epithet 'genius' with little, if any, opposition from others (save perhaps from his contemporary rival Leonardo da Vinci (1452–1519) and himself) – is almost impossible to do with any sense of measure, grandeur and justice. Along with a small number of contemporaries, Michelangelo was responsible for Renaissance Florence becoming the artistic fountainhead of western culture. He was a man of incredible talent: not only was he a revered sculptor, but also a fantastic painter, draughtsman, architect and even poet. His depictions fo classical and Biblical scenes are unparalleled in their beauty.

Humanism Strikes a Divine Chord

No single man has better exemplified a person as artist than Michelangelo di Lodovico Buonarroti Simoni (1475–1564) and no artist, scholar, critic, thinker or simple lover of art can ignore the man when asking fundamental questions in any appreciation of artistry and its relationship to life: What makes an artist? What is art? What is man's purpose on earth?

Of course, there were formidable artists who came before him, like Cimabue (*c.* 1240–1302), Giotto (*c.* 1267–1337), Lippo Memmi (*c.* 1291–1356), Fra Angelico (*c.* 1395–1455), Andrei Rublev (*c.* 1365–1430), Sassetta (*c.* 1390–1450), Paolo Uccello (*c.* 1397–1475) and Jan van Eyck (*c.* before 1390–1441) to name a few, not to mention the largely forgotten names of Greek and Roman artists of old.

Arising from pagan Antiquity to Christian Western art into Medieval times, through its massive public edifices and churches, the social and intellectual shift toward humanism – the belief that human intelligence and reason can determine one's life in the place of divine gods or

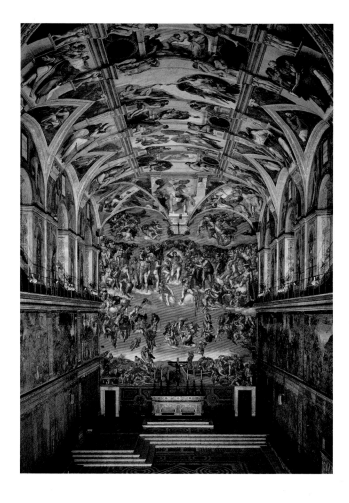

sacred religions – altered human endeavour in all fields of thought, design, religion, literature and art. Various forms of humanism dominate our philosophies to this day. Doubt and an empirical look at the self and the universe emerged from classical studies to form early humanism, the crucial cultural movement of the Italian (European) Renaissance.

High Renaissance Man

The roughly three-century period known as the Renaissance put an end to the Middle Ages, and the years between *c.* 1490 and the 1520s were the era's high point. Known as the High Renaissance, in addition to advances in cultural philosophy, science, design, urban planning, republican politics and warfare, these years saw perhaps the most visible advances in the leaps and bounds taken in art – sculpture, painting, fresco and architecture. While Leonardo da Vinci and Raphael (1483– 1520) were also considered geniuses (many thought them greater in certain respects than Michelangelo), neither equalled Michelangelo's mastery of so many artistic disciplines. Be that as it may, none of them, including our 'divine master', could have achieved what they accomplished without the others. This brief introduction, aside from an occasional anecdote involving other great thinkers and artists, is meant to outline the life, times, psyche and creations of Michelangelo.

Reaffirming an idea from the philosopher of history and art historian R.G. Collingwood (1889–1943), Michelangelo was a sculptor, painter, poet, architect and engineer of the High Renaissance who greatly expanded the language of Western art –

combining the sacred and the humanist, the inspired and the scientific; Michelangelo gave us the means of 'acquiring new emotions and new means of expressing them'.

City States and Patrons

The concept of the individual artist, much as it is still defined today, took shape during the early stages of the Italian Renaissance. The Church and the state gave rise to self-governed city-states that introduced humanism into the forces of divine power through financial and artist-guild rule. The individual citizen-artisan, still emerging from the contradictions and power struggles of these highly stratified city-states, was perhaps first defined by those who commissioned works by the Church; state and private patrons then came to bestow upon persons without rank a place and voice in this new society. While the Church still dominated the subjects of Western art, their representation and setting, artisans began through ancient and new techniques to add self-expression to their craft and to bring art into public spaces, squares, gardens and galleries.

The Medici Family: Bankers, Rulers, Patrons

The Renaissance, as we know it, is inconceivable without the bourgeois family of the Medici that ruled Florence and then Tuscany almost interrupted from the 1430s to the 1730s. Their reign was obstructed only twice by their Florentine rivals, the noble House of Albizzi, in the early sixteenth century for a mere 20 years. Regent queens Catherine de' Medici (1519–89) and Marie de' Medici (1573–1642), both married into the royal families of France, and the family produced four popes for the Church: Leo X (1475–1521), Clement VII (1478–1534), Pius IV (1499–1565) and Leo XI (1535–1605).

The history of the Medici family started in the thirteenth century and it soon rose through humble and industrious beginnings in banking and commerce to become one of the most influential houses of Florence. Another branch of the family that signalled the start of the great Medici dynasty – following the older Medici family decline in the early fourteenth century — was led by Cosimo the Elder (1389–1464) who rose to political power in 1434 and ruled Florence as a monarch without a crown for the rest of his life. Cosimo was a devoted patron of the humanities, and supported artists such as Brunelleschi (1377–1446), Donatello (1386–1466) and Fra Angelico (c. 1395–1455). Upon Cosimo's demise, after a short-lived rule in Florence, his son Piero, known as the Unfortunate (1472–1503), was briefly exiled, and left Medici rule in a state of limbo until his son (and Cosimo's grandson), Lorenzo the Magnificent (1449–92), assumed power in 1469. Renaissance culture once again flourished, and Florence became the cultural centre of Europe.

trade guilds and the increasing intellectual and physical skills of its works, the shift from artisan to artist began, allowing for previously mentioned artists and geniuses to begin to shape both the urban landscape and the city into a living museum of wonders. Cosimo the Elder's belief in the institution and power of art patronage forever changed the way Western art entered the world, both physically and spiritually. His grandson turned this into an inescapable reality.

Lorenzo had a huge collection of antiquities that included marble sculpture, gems and vases. He urged contemporary artists to study and gain inspiration from antiquities, at considerable cost to himself. He designed a sculpture garden at San Marco, where he encouraged Michelangelo to carve his *Madonna of the Stairs*, 1490–92 (*see* above) and *Battle of the Centaurs*, 1491–92 (*see* page 10). Michelangelo was part of Lorenzo's coterie, along with humanist scholars and poets. This association both increased Lorenzo's collection and commissions, and changed the nature of art patronage.

Lorenzo the Magnificent as Head of State

The importance of the Medici family cannot be overestimated in any discussion of the individual artists and thinking of the Renaissance. Their astute banking practices and political acumen, equalled only by their passion and skill at collecting art, the sum of which many Florentines would condemn as opportunistic and unholy, nevertheless paved the way for a humanistic, secular society that has been in constant development to this very day. With the rise in power of the

A Secular Genius

In short, to understand the rise of art and its power in the Renaissance, the importance of the courts, its rulers and patrons cannot be neglected. The power plays between patrons and Church leaders, humanism and religion became intertwined, sometimes for better, sometimes for worse. Without pretending to deal with the whole vast complex of ideas, phenomena both material and spiritual, politics, warfare, sexuality and the emergence of the modern individual – artist,

decision-maker, banker, worker, commoner, merchant, bureaucrat, husband and wife, son and daughter, and so on – there is no question that Michelangelo is a compelling and emblematic figure through whom to study both past and present.

It may have been the spirit of his times to call him divine – and no doubt the nature of much of his work led to that conclusion – but Michelangelo was first and foremost a determined, highly skilled thinker and maker, a man whose claim to be called a secular genius remains unparalleled.

The Boy Michelangelo

On the surface, the early childhood of Michelangelo does not appear to be one of the happiest – ironically, it bears a resemblance to that of many of today's modern poor, stricken with a parent's illness at birth and saddled with a father having a hard time making ends meet.

On account of his mother's illness, the young boy was soon placed in the care of a family of stonecutters. The neighbouring mother served as Michelangelo's wet-nurse and the boy spent his days, as he – though not particularly noted for his sense of humour – later joked, '[sucking] in the hammers and chisels I use for my statues'. It was clear that upon entering grammar school the boy was more interested in studying churches and watching the masons, sculptors and painters ply their crafts than attending class. When Michelangelo turned 13, his father – against his better judgement – allowed him to be toapprenticed in the atelier of the fresco painter, Domenico Ghirlandaio (1449–94), who also played an important role in the early Florentine Renaissance with Sandro Botticelli (1445–1510).

Ghirlandaio and the Medici 'Academy'

Around 1488, Michelangelo was thus brought into the Ghirlandaio workshop where he studied sculpture and painting before being discovered by Lorenzo the Magnificent and introduced to the Medici court from about late 1489 until Lorenzo de' Medici's death in 1492.

At the Medici's 'Platonic Academy', Michelangelo sculpted the reliefs *Madonna of the Stairs* and *Battle of the Centaurs*. Legend also has it that one of the first pieces seen by Lorenzo was the head of a satyr sculpted by the young Michelangelo that met with playful derision from Lorenzo. While clearly moved by the young artist's skill, Lorenzo pointed out that the old satyr had remarkably fine features and beautiful teeth for such an aged lecher. The proud Michelangelo, who was soon to become known then, and throughout his life, as being highly critical of others and equally intolerant of the criticism of others, took back the effigy of the Greek follower of Dionysus, roughed it up and broke a couple of its teeth before returning the head to the delighted Lorenzo.

It should be noted that Lorenzo de' Medici's artists, statesmen, thinkers, groundskeepers, masters and the like sat together in what is closest to that which today exists as elite schools of fine arts. The garden near San Marco was both school and living museum, and included the presence of many of the greatest minds and artists of the times.

In addition to a garden for the antiquities, works of art and artists, and rulers, cardinals, thinkers and popes-to-be, the 'Academy' was a vibrant think tank coming to terms with a renewed interest in pagan Antiquity, the religion of the Middle Ages, the emerging humanism of the day, and plans about the world to come. While technology had not reached the mechanical sophistication of today, innovations in architecture, advances in chemistry and physics, and thoughts about humankind's place in the world were a matter of daily travail and seriousness. This was also at the source of the intellectual, spiritual and political crises in both individuals and states that continue to plague and entice our modern world. Michelangelo played an active role in confronting all of these crises.

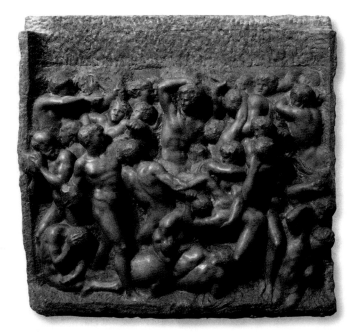

Lorenzo: the Man of Arts

Lorenzo the Magnificent was known to have the gift of putting people at their ease and of facilitating open-minded discourse, both serious and playful. Everything in life was sentient in this world and had a place in an exciting realm of life, study, work and love. Learning was a supreme virtue – banking, it seemed, merely paid for it.

There is no doubt that Lorenzo de' Medici was a hedonist, but he was far from being a man without religious spirit and soul. Some would suggest that his hedonism and his ostentatious of love of material objects led to his demise and the return of a strict man of the scriptures, the Dominican friar Girolamo Savonarola (1452–92) before and up to the time of Lorenzo's death.

Indeed, Lorenzo loved of the company of others – the erudite, his family, artists, scientists, architects, gardeners, bright young men and beautiful women. This is most apparent in the gallery of works that arose from artists Botticelli, da Vinci and Michelangelo.

The Spirit of Enlightenment

Whatever the merits of their individual works of art, it is hard to imagine today such a small group of artists being so important in the decision-making process regarding faith, individual freedom, beauty, and the very nature of society as a whole. Michelangelo's early efforts to mix Western secular culture, the old and the new, along with those of other artists and powerful figures of the age, turned the High Renaissance into a historical movement that dramatically enacted humankind's loftiest ideals and cruellest tragedies on the same stage for all to see. The public and the private had never before been so inextricably intermingled.

This play was not an act of protest, but a vision that came from and further defined a humanism that was meant to come into being at that time. It needed Michelangelo and other great artists to give it visual reality.

Walter Pater (1839–94) wrote: 'The fifteenth century in Italy … is an age productive in personalities, many-sided, centralised, complete. Here, artists and philosophers and those whom the action of the world has elevated and made keen, do not live in isolation, but breathe a common air, and catch light and heat from each other's thoughts … The unity of this spirit gives unity to all the various products of the Renaissance; and it is to this intimate alliance with the mind, this participation in the best thoughts which that age produced, that the art of Italy in the fifteenth century owes much of its grave dignity and influence.'

Questions about, and choices regarding, faith and individual sexuality were both tolerated and condemned. The media has changed, but although our struggle for tolerance and equality is carried out in a

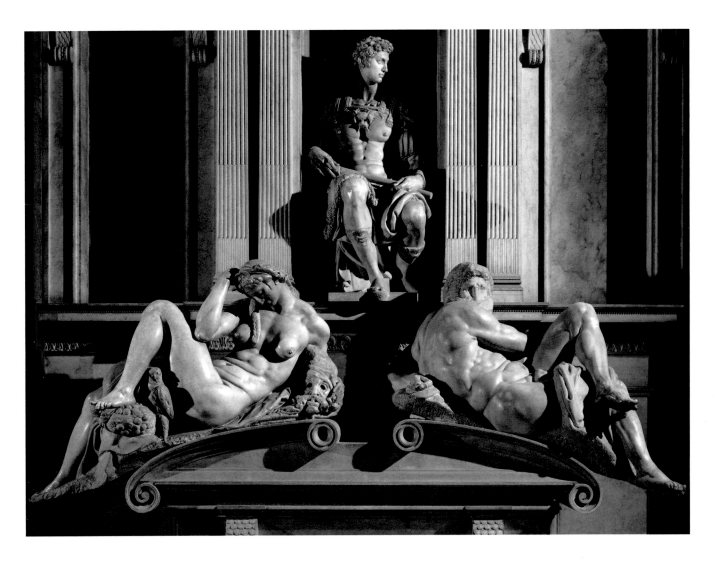

different fashion today, the fundamental issues are basically the same. Homosexuality (the importance of which will become apparent regarding Michelangelo later) was illegal, yet widely practised in youth and largely accepted. Labelling was not an issue of major concern then, and the means to spread the news were less ubiquitous; therefore sexuality remained largely a private matter.

And for the first major period since Antiquity, the belief in a monotheistic god – who accounted not only for one's total existence but also for one's questions about individual origins, private and social behaviour, good and evil – was questioned, debated and discussed in both private and public forums. There is no question that the subjects of Western art were soon to become all that was visible and conceptual, above and beyond the religious, symbolic and iconic. Again, the work of Michelangelo brought this verbal discourse to visual reality.

In the Company of Il Magnifico, Lorenzo de' Medici

Il Magnifico was the secular saint of the High Renaissance. The Medici family's reputation and wealth alone were enough to influence and satisfy the loftiest of politicians and leaders. However, Lorenzo and his

mother Lucrezia also shared a passion for poetry, in particular Dante (*c.* 1265–1321) and Petrarch (1304–74). They not only reignited an age's interest in literature but also produced some of its remarkable poetry.

Few people seem to have a better grasp the great age of the Renaissance than nineteenth-century author Walter Pater in *The Renaissance: Studies in Art and Poetry* (1873): 'The various forms of intellectual activity which together make up the culture of an age, move for the most part from different starting-points, and by unconnected

roads. . .Art and poetry, philosophy and the religious life, and that other life of refined pleasure and action in the conspicuous places of the world, are each of them confined to its own circle of ideas, and those who prosecute either of them are generally little curious of the thoughts of others. There come, however, from time to time, eras of more favourable conditions, in which the thoughts of men draw nearer together than is their wont, and the many interests of the intellectual world combine in one complete type of general culture.' One man, Michelangelo, combined all aspects of this 'general culture'.

The Last Home of Lorenzo de' Medici

Lorenzo de' Medici was at home in his 'Academy' with his family, friends and intellectual peers. Though while he was clearly in part a materialist, he was also a poet, and he, like just about every man of his times, had a strong sense of religion. Though somewhat odd bedfellows at times, humanism and religion were not incompatible.

Lorenzo de' Medici received the Last Sacraments as a devout and pious man. The fact that upon his deathbed Il Magnifico sent for the zealot Savonarola may have been Lorenzo's confession that he had failed to unite humanism and religion with the true republican way of life. Be that as it may, Savonarola's outspoken condemnation of secular Florence and the iniquities of ecclesiastical Rome gave no peace to the so-called tyrant and frivolous de' Medici. Little is known about what was actually said between the two men, but Savonarola announced the apocalyptic return of God's judgement and, with the help of the King of France, Charles VIII; Lorenzo's son Piero de' Medici was hastily exiled.

The State in which Michelangelo Thrived

As we focus primarily on the life of Michelangelo – the man, the artist, the genius and the divine – it is worth noting that Savonarola continued his fundamentalist religious battle with the Church and state until the friar was finally excommunicated, sentenced to death, hanged and burned in 1498. With the Medici family fortune in ruins, Piero de' Medici in exile, the lasting influence of Savonarola, who had become a sort of martyr, and the 'avenger' King Charles VIII in Florence, it appeared that the reign of the Medici had come to an end.

But another son of Lorenzo de' Medici was not to be forgotten. Having been appointed cardinal as a boy by his father, in 1512 Giovanni de' Medici convinced the pope to allow the family to return to Florence with the backing of the Spanish Army.

It is by no means irrelevant to look at the reign of the Medici family in some length, because so many of its issues of state were also issues of Michelangelo the man. While Michelangelo is arguably one of the most well-known and respected artists of all time, this is not merely because of his work and the objects he left behind, but because the High Renaissance continues to shape so many of the issues we face today, in an age in which we still struggle with what it really means to be humanists and how that should be made manifest in our social and spiritual behaviour, our physical and material evolution, and our private and public humanity.

Art, like all great human endeavours, is no doubt a symbol of power and wealth; it is also a reflection of our being and the image we wish to present to the world. No artist's works have accomplished this so powerfully and gracefully as those of Michelangelo.

Interest in Anatomy

Throughout his life as an artist Michelangelo showed a keen interest not only in the tools of his craft – stone and chisel, colour and light, shape and volume – but also in anatomy. Meetings with physician-philosophers at the court of Lorenzo de' Medici led him to study, and soon to dissect, cadavers from the church morgue, a practice tolerated but hardly sanctioned. It is said that Michelangelo dissected anything he could get his hands on; many believe his medical problems with gouty arthritis and kidney dysfunction led to an increased interest in the matter.

Savonarola's Influence

It is also no stretch of the imagination to suggest that Michelangelo's lifelong battle with self-abnegation and Christian faith drew him close to the inner workings of the severe Savonarola, a man whose ideas were a constant source of reflection despite Michelangelo's upbringing with the far more tolerant and humanistic Medici family.

After the exile of the Medici family from Florence following Lorenzo's death, and Michelangelo's stay in Bologna in 1494–95 where he worked on figures for the tomb of St Dominic, Savonarola made his move on Florence. When Michelangelo returned in late 1495 the friar had begun to stage his 'Bonfire of the Vanities' (in Italian, *Falò delle vanità*), which were public gatherings and burnings of thousands of objects – mirrors, playing cards, cosmetics, fine clothes, works of art, musical instruments and other objects that represented deviations from a simple pious life devoted to following the word of God. One was meant to live in faith and sacrifice. It has even been said that Botticelli

wilfully burned some of his paintings to ward off anything that may have been construed as a temptation to sin. Meanwhile, Michelangelo began his sculptures *St John the Baptist,* 1495 and *Sleeping Cupid,* 1495.

Judging from Michelangelo's works, letters and life, and from what some consider the tragic execution of Savonarola in 1498, humanism proved to be a stronger mate for religion than expected and extreme fundamentalism would not have its final say in the High Renaissance.

'The Foot is More Noble than the Shoe'

But there was no fear that Michelangelo's personal appearance would succumb to finery, even during times of extreme wealth. He was known to sleep and work in his boots and clothes, was unkempt, and generally paid little attention to his outward appearance. In his words, 'What spirit is so empty and blind, that it cannot recognize the fact

that the foot is more noble than the shoe, and the skin more beautiful than the garment with which it is clothed?' What mattered to the artist was what he saw inside his soul and in the world and people outside him. Few artists of any era can match his acute vision of the forms and nature of the human body. As he stated, 'One cannot work at one thing with the hands, and at another with the brain, especially when marble is concerned.'

The *Pietà*

While Leonardo da Vinci was largely considered the brightest scientist-artist of the era, Michelangelo was no less of an observer, a quality that no scientist can proceed without. His powers of observation, his ability to depict human flesh both in stone and in paint, is stunningly apparent in his first major work, the *Pietà,* 1498–99 (*see* below), a moving portrayal of the dead Christ being cradled in the Virgin Mary's arms that has lost none of its sublime power throughout the ages.

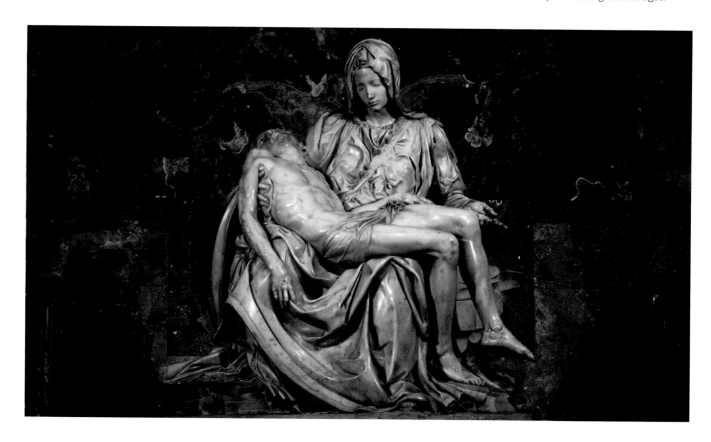

The *Pietà*, which signifies pity and compassion, was a common subject amongst European artists, but none can equal Michelangelo's rendering that was first commissioned for the smaller St Peter's Basilica and now remains in the enlarged St Peter's Basilica in the Vatican, Rome.

It is hard to imagine today just how skilfully and gracefully the young artist was able to transform the cold majestic marble of Carrara into seemingly still warm flesh. Christ's death is made all the more sentient by the distribution of his body weight in his mourning mother's lower body, arms and hands. The Virgin Mary conveys the weariness of holding not only a life-like body but also a history of a world transformed. While the two figures do not meld together, they lean or rely on one another, inseparable, eternally alive. Never before had sculpture been able to project the breathing sensorial immediacy of painting, an immediacy which prompted an argument that has for over 500 years raged between artists, critics and historians as to which of the two – Michelangelo or da Vinci – is the greatest artist. It may appear fruitless to try and compare the very different media of paint and stone, but the *Pietà* clearly triumphs over the unbelievable difficulty of creating such intricate, soft life out of the hardness of marble.

Many were in awe of such mastery, so much so that upon hearing a group of spectators praising loudly his masterpiece and attributing its maker to 'Our Gobbo of Milan', Michelangelo stole into the chapel at night and carved his name on it, a signature he would never again (nor need to) repeat throughout his long, productive life.

David

The facts of Michelangelo's commission to sculpt *David*, 1501–04 (*see* right and page 16) are straightforward and simple. The results are not; in a word, the results are history. In 1501 the city of Florence commissioned the then relatively unknown sculptor with one major work to his name – the *Pietà* – to carve the *David* that was meant to stand high atop the Duomo, Florence's main cathedral.

The massive block of marble (over 18 feet high) had been abandoned for a decade and two sculptors had failed to give it life. But the city would not give up, in part because of the cost of quarrying such a great

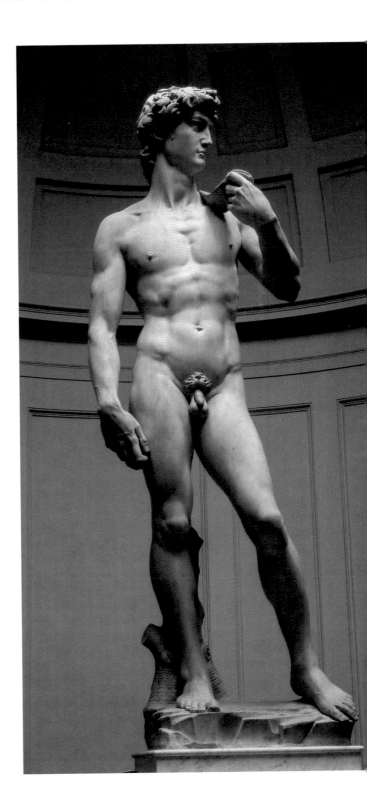

piece of stone. Thus Michelangelo set to work, completing his masterpiece three years later. Nothing from marble had been seen like it before, especially if one considers the tools with which it was hewn.

Given the state of the marble block, the size of the resulting structure (17 feet) and the almost non-existent margin for error in carving stone into the likeness of bodily flesh, Michelangelo had to call upon not only the consummate skill of his artistry (still in its infancy), his study of anatomy, his reputation, his vision and, perhaps most of all, his faith that what would become the symbol of the republic of Florence and the greatest sculpture ever created by a single man could be accomplished by a few chisels, human hands and the mind alone.

That it was like nothing that had ever come before it, we know. The city of Florence immediately rejected its first idea to place the sculpture high above gazing eyes and set its almost god-like form for all to see in the Piazza della Signora. Centuries later, in 1873, it was placed in the Galleria del'Accademia where it still stands today. A replica has been at the Piazza della Signora since 1910.

But Michelangelo himself often expressed a reserved and muted appreciation of being called a genius, and it is hardly imaginable that he took the epithet divine seriously. That he felt blessed at times is certain, but he could also on occasion feel cursed. Michelangelo was, it appears, both an extremely humble man and an extremely irascible one. It is likely that his cosmic anger came from the enormity of his challenging work.

Mark Twain reported that Michelangelo told Pope Julius II: 'Self-negation is noble, self-culture beneficent, self-possession is manly, but to the truly great and inspiring soul they are poor and tame compared with self-abuse.' It is doubtful that the artist walked away from his *David* with that feeling of self-abuse alone, yet he seems not to have turned back; he continued throughout his life to face even greater challenges, if that can be considered possible.

The Lasting Impact of *David*

By working on and succeeding in creating masterpieces of his first two major sculpture commissions at such an early age, Michelangelo not only laid down a path and discipline from which he would never waver, but he also gained the skill and confidence in his work which many take a lifetime to achieve, and others betray because they mistakenly believe they can never better what they have already created.

Michelangelo, da Vinci and Botticelli have all at one time or another been likened to superstars in the modern sense of the term – each had been or remained extremely sought after and wealthy – but above all they remained artisans in the service of the Church, the city or the patrons who represented the body politic. The late Middle Ages and the early Renaissance gave rise to the fame of individual artists, much as we see today. But it is hard for us to imagine the completeness of the man – the (High) Renaissance man – to which these multi-talented workers of the matter and mind gave 'stardom'.

As a single look can attest and as many artists, critics, and historians describe, *David* is unquestionably one of the greatest single works of art of all times. But *David* was not merely a great work of art, it was the personification of an allegory from biblical times that brought the sacred closer to the human, that confounded the notion of divine will by making a victor, a hero and a king of a simple shepherd; a shepherd with God on his side no doubt, but nevertheless one who, unlike Jesus, was a mortal man.

It appears that Michelangelo's larger-than-life *David* exists on the very edge of a battle that would change the course of human nature. He knew his opponent was brawny and uneducated, and that the fate of his people, indeed of all humankind, would suffer if he allowed the might and boorishness of warriors to rule over God-fearing people. Goliath, armed to the hilt, stood in the middle of the battlefield for days seeking a single challenger. King Saul knew there was no one among his men capable of defeating the mighty giant warrior.

Divine Harmony

Could this have been the first sign that religion was not enough for humankind to survive, prosper, develop and evolve in peace? Was David's act of courage the first major work of Western art – both as a story and as an example of divine harmony? Certainly, it seems that Michelangelo brought his *David* to the height of perfection, the work of a man perhaps with the aid of the unseen hand of God. This is the very question that divides religion and humanism. And it would haunt the artist Michelangelo throughout his life.

But what is perhaps so truly astounding about *David* is that what we see, the visible art, is the body and mind of man poised at the edge of an impossibly perfect action. Armed only with a leather strap to sling a single rock at a heavily clad and armoured fighting machine, David was not merely the physically weaker victor over the strong, as our general comprehension of the biblical story would have it. He not only knows he will win; he knows he cannot lose. For the sake of our narrative, set aside for a moment that David has God on his side. Imagine that the biblical David's faith is closer to that of the man Michelangelo than to the scripture.

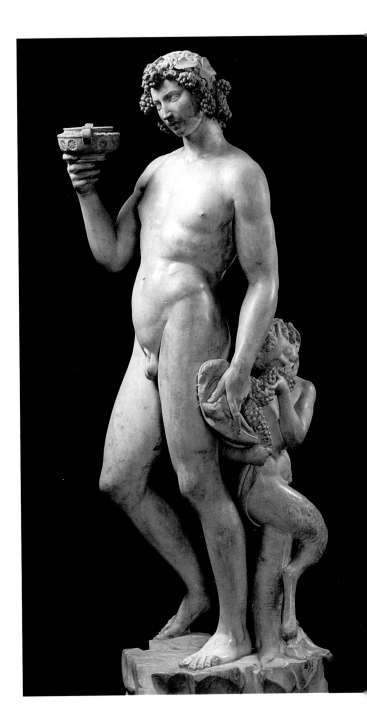

Take one look at the *David* in the Galleria del'Accademia in Florence and we know that the human as artist and thinker has won. And Michelangelo proved it.

Michelangelo in Fits and Starts

The artistic career of Michelangelo is made up of as many, or more, interruptions and aborted projects than those achieved to his satisfaction. Such was also the fate of artists bound to the fortunes of churches, states and patrons. How much more he could have accomplished is another matter, for it has been said that plans for the tomb of Pope Julius II alone called for 20 life-size figures in marble, more than enough for a full lifetime of carving – even more, when one takes into account that Michelangelo, almost alone among his peers,

went on long dangerous missions to quarry the precise stone he wished to use. Michelangelo stated: 'The best artist has that thought alone which is contained within the marble shell. The sculptor's hand can only break the spell to free the figures slumbering in the stone.' He also beseeched the Lord to grant 'that I may always desire more than I can accomplish'. Whether this wish was always granted by the Lord is another matter, for popes and patrons were known to provoke his ire, and duties of state to take away his precious time, but never has it been suggested that Michelangelo grew weary of a vision that lasted nearly 89 years.

In 1497 the artist sold his first important work to a banker-patron, a Bacchus, the Roman god of agriculture and wine, akin to the Greek Dionysus. He also sculpted a cupid, which has been lost. While his *Bacchus* (*see* page 17) shows admirable skill and reaches anonymous Classical standards of excellence, no one could have foreseen the leap he achieved a mere year later with the *Pietà*.

Minor Works

After the *Pietà*, his first masterpiece, Michelangelo did not receive a commission until he was called to Florence to create a bronze of David that was ultimately finished by another hand, and his *David* which stands to this day in Florence, the city for which it was designed. Little today is said of the *Twelve Apostles* (in marble) ordered during this time by the Cathedral Cabildo, of which only St Matthew was begun. And as he was working on the *David*, Michelangelo managed to paint his only easel painting that we know to have survived, the *Doni Tondo* (*see* page 105), an oil on wood panel of the Holy Family, presently on display at the Uffizi Gallery in Florence.

After setting up his *David* in front of City Hall in 1504, Michelangelo was commissioned to paint a fresco on a wall of the Florence Council Room. This went unfinished, as did two marble reliefs. He did manage to finish a rather banal marble *Madonna with Child* (*see* right), which was expedited to Bruges, Belgium where it still resides.

And so it goes. For someone who had recently finished two of art's greatest masterpieces, what would a few years and missed opportunities matter? But for Michelangelo, 'there is no greater harm than time wasted'. Idle hands can lead to no good.

Disappointment and Ire

In 1506 it appeared that Michelangelo's wait was over. Pope Julius II called him back to Rome to start work on his massive tomb of some 20 life-size figures. Michelangelo spent nearly a year in Carrara quarrying for the marble he desired and upon returning to Rome started blocking out some of the figures.

Again, for a number of reasons to this day not satisfactorily explained, the project was abandoned. Romain Rolland (1866–1944), French dramatist and recipient of the Nobel Prize for Literature in 1915, blamed Donato Bramante (1444–1514), who, out of jealousy, convinced the pope to reconstruct St Peter's Basilica according to his own plan (which was done, one for Bramante to see it executed by Michelangelo) and to abandon, at least for the time being, the tomb. 'Michelangelo,' wrote Rolland, 'was not only humiliated and disappointed, but in debt.' He had to pay for the transport of the marble from Carrara and house the stonecutters who were arriving from Florence. Michelangelo continued, 'I urged the pope as strongly as I could to continue the construction of the tomb and then one morning when I wished to talk to him about it he had me put out by a groom.'

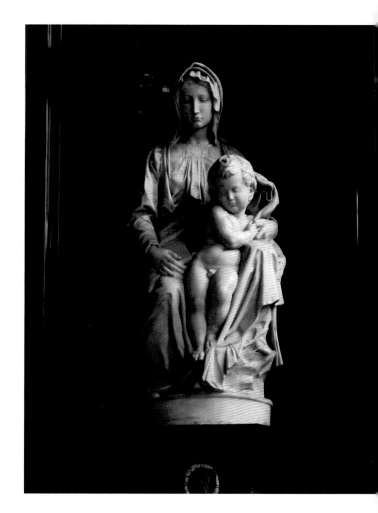

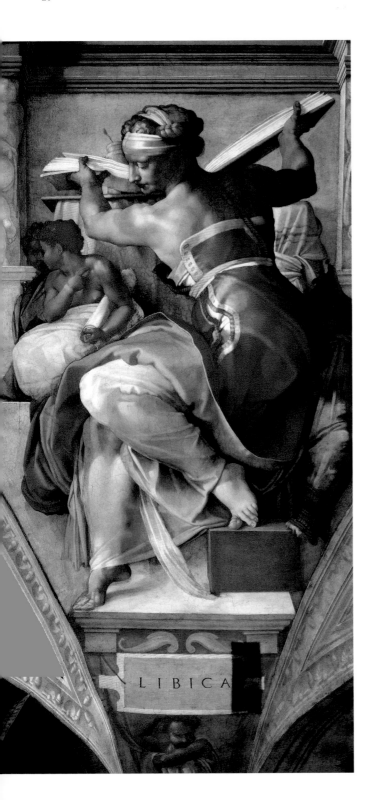

LIBICA

Full of ire and to anger the pope, Michelangelo left Rome and sought refuge and protection in Florence. He then went to Bologna to apologize to Pope Julius II, was pardoned, and was given a commission to create a grand bronze sculpture of the pope. Michelangelo spent over a year modelling and casting the figure, only to see it too abandoned and melted down to become a cannon a few years later.

Little did Michelangelo know that this series of interruptions, losses and forever wasted hours of time would, in 1508, lead him to the ceiling of the Sistine Chapel where one of the world's greatest man-made wonders exists to the glory of God and humankind.

The Sistine Chapel: Learning to Paint

Michelangelo was reluctant to begin the frescoes for the Sistine Chapel in the Vatican (*see* pages 28–77), which had been named after Pope Sixtus IV, the apparent reason being that he considered himself foremost a sculptor not a painter. But although it would mean more delays to working on the Pope's own tomb, it was unlike Michelangelo to refuse a challenge. In fact it is thought that he negotiated to be allowed to paint a more complicated ceiling design than Pope Julius had originally envisioned.

Still, the technical difficulties of fresco painting were formidable, and that they would be painted high above the ground, standing in an awkward back-breaking and unnatural posture, would have been a great feat even for accomplished painters such as Raphael and da Vinci. Michelangelo had his work cut out for him and much to learn. He would spend four full years doing just that.

Giorgio Vasari (1511–74) writes an account of the start of the Sistine works which reveals the difficulties – both personal and technical – that Michelangelo was facing: 'The pope commanded Bramante to make preparations for the painting, and he hung a scaffold on ropes, making holes in the vaulting. When Michelangelo asked why he had done this, as on the completion of the painting it would be necessary to fill up the holes again, Bramante declared there was no other way.' Bramante's known jealousy and the belief he held that Michelangelo did not deserve such great favours from the pope, led Michelangelo to believe,

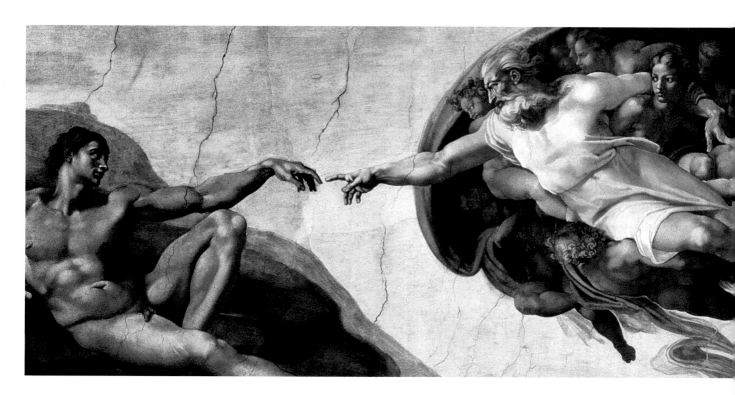

with no little reason, that he was being undermined by a lesser artist. He expressed his concerns to the pope. Vasari goes on to say: 'The pope answered, in Bramante's presence, that Michelangelo should design [the scaffolding] for himself.' So Michelangelo erected a system that did not touch the walls, a method that was later widely used by other artists, even Bramante himself. Vasari, clearly amused, said that Michelangelo 'gave so much rope to the poor carpenter who made it, that it sufficed, when sold, for the dower of the man's daughter.'

Michelangelo then set out to draw the cartoons for the ceiling frescoes. His problems were far from over. Vasari reported: 'The pope wanted to destroy the work on the walls done by masters in the time of Sixtus, and he set aside 15,000 ducats as the cost, as valued by Giuliano da San Gallo. Impressed by the greatness of the work, Michelangelo sent to Florence for help, resolving to prove himself superior to those who had worked there before, and to show modern artists the true way to design and paint. The circumstances spurred him on in his quest of fame and his desire for the good of art.' After having completed the cartoons, Michelangelo decided to call on some painter friends of his

from Florence, both to receive valuable help from them and to learn more about fresco painting from proven artists. He started them off with some specimens but was terribly disappointed. Vasari concludes his story, writing that: '[Michelangelo] decided one morning to destroy everything which they had done, and shutting himself up in the chapel he refused to admit them, and would not let them see him in his house ...and so they took their departure, returning with shame and mortification to Florence.'

There would be similar troubles at the beginning and further obstacles to overcome due to the nature of the Roman lime used to cover the ceiling. Despite objections and lengthy discussions, including more of Bramante's interference – who openly wished for Raphael to do at least half the ceiling – Michelangelo took matters into his own hands, relied on very few assistants and did all but the most menial work himself. This was typical of his oft-considered arrogant nature, though many great artists not only understood but also admired him for it. Raphael was one of these. And Michelangelo clearly took lessons from Raphael, da Vinci, and others, but through observation more than collaboration.

The Sculptor as the Artist

Much has been made of the fact that Michelangelo excelled as a sculptor and brought the qualities of that art to painting. There is no question that the ceiling of the Sistine Chapel brings out the three-dimensional qualities of his painting, both single figures and full set stages. He is said to have 'carved' his images out of paint. Again there is truth to that.

But this appreciation of his painting seems to comply too easily with Michelangelo's self-derision, and forgets to account for the extraordinary skill of line, balance, strength, suggestion of motion and – what came as a surprise to many at the time of his work on the Sistine Chapel – his harmonious use of colour. Above and beyond all the disparate skills needed to bring together a painting, who could imagine the daring and provocative stage that Michelangelo set in the three main panels that overlook the seats where Christian cardinals choose His Holiness, the Vicar of Christ?

Jesus Christ does not appear on the ceiling painting (because this narrative comes from the Old Testament Book of Genesis). Christ only appears by Michelangelo's hand at the Sistine Chapel many years later (c. 1535) when work began on *The Last Judgement* (*see* below and pages 80–94). Twenty years after Michelangelo had completed the ceiling, Clement VII (1478–1534) asked him to return to paint the far wall of the chapel. Clement VII was presumed to be assassinated by poison just a few days after having commissioned Michelangelo, though this remains unclear. At any rate, Michelangelo began and completed his work at the Sistine Chapel under Pope Paul III (1468–1549).

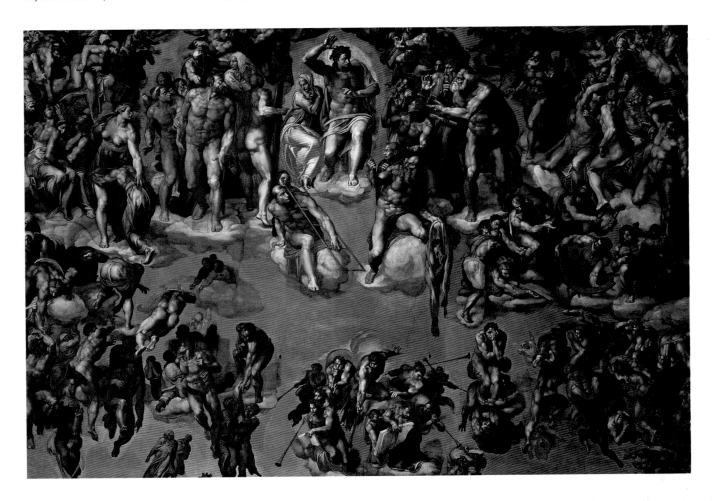

Genesis: A Biography

The ceiling is, in effect, an adept pictorial narrative of Genesis from
the moment that God separates light from dark (*see* page 32), to the
celebrated creation of Adam (*see* page 36), to the temptation and the
expulsion from the Garden of Eden (*see* page 42), to end on the scenes
in the central panel with the story of Noah (*see* pages 45–47).

On the two side panels, the prophets and soothsayers foresee and
announce the Coming of Christ (*see* pages 48–77), which could later be
seen in Michelangelo's hand when he completed *The Last Judgement*.

The amount of painterly detail is too vast to describe here and will be
briefly elucidated in close shots of Michelangelo's works included in
this book. What appears crucial is to imagine Mchelangelo's art as a
culmination of his passion for art, politics, religion, humanism, sexuality,
character and faith. Like his statue of *David*, it does not take much to
make the moving picture of the Sistine Chapel paintings representative
of his – indeed any person's – life or biography.

Author and critic Andrew Graham-Dixon wrote: 'I found myself
wondering, why did Michelangelo have God create Adam with a
finger? In other representations, for example, if you look at Ghiberti's
doors in Florence, God raises up Adam with a gesture of his hand.
And as I turned over various ideas and theories, I began to see it as the
creation of the *education* of Adam, because that's the symbolism of the
finger. God *writes* on us with his finger, in certain traditions of theology.
In the Jewish tradition, that's how he writes the tablets of the Ten
Commandments for Moses – he sort of lasers them with his finger.
The finger is the conduit through which God's intelligence, his ideas
and his morality seep into Man. And if you look at that painting very
closely, you see that God isn't actually looking at Adam, he's looking
at his own finger, as if to channel his own instructions and thoughts
through that finger.'

In the halls of the Sistine Chapel we are witness not only to the story
of a religion and a civilization, to an age at the birth of complex self-
awareness, but also to the troubles of the world at battle with the
equally dark troubles of the divine.

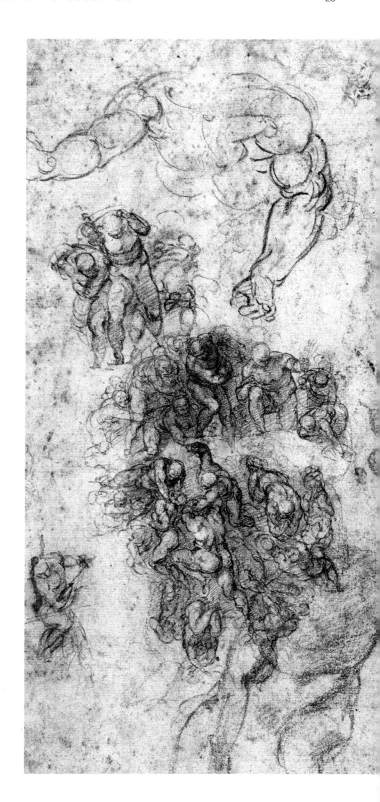

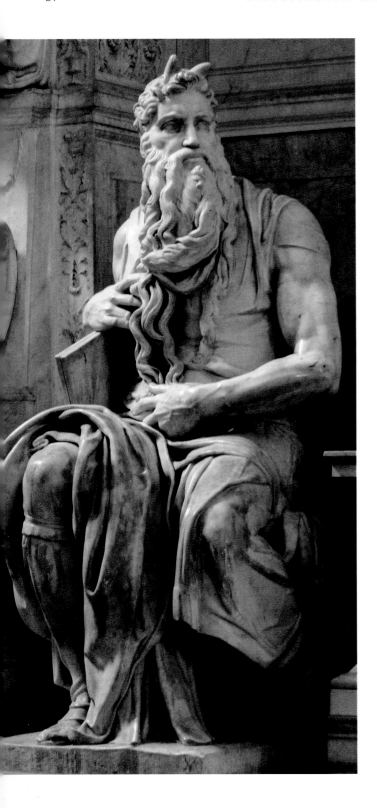

Moses

At the death of Pope Julius II, Michelangelo signed a new contract with his heirs to complete the tomb he had begun before embarking on the painting of the Sistine Chapel ceiling.

One of the major works of this period was his *Moses* (*see* left), a massive sculpture that has Moses seated, 8 feet high. It is only a small portion of the planned tomb for Pope Julius II and is the chief attraction at the church of San Pietro in Vincoli, Rome.

One of the surprising and unmistakeable elements in this sculpture are the two nascent horns emerging from the head of this powerful and angry figure. These have been attributed to a mis-translation of the Hebrew word '*qaran*': while it has been mis-translated as 'rays of light' coming from the head of Moses, the principle meaning of '*qaran*' in Hebrew is 'horn'. These horns have been seen in other depictions of Moses. In the Bible the figure comes from the Old Testament Book of Exodus. Moses has just left the Israelites, whom he delivered from slavery in Egypt. Two of these sculpted slaves can today be seen in the Louvre in Paris. Moses is heading to the top of Mount Sinai to receive God's commandments and upon returning finds that his people have constructed a golden calf, a pagan idol to worship. His fury knows no bounds and yet he is remarkably restrained.

It appears that the seated Moses is witnessing this scene for the first time and contemplating his action. The sculpture itself – that is, Moses – looks as if it is about to rise. In the Book of Exodus, Moses, '… in terrible anger … threw the stone tablets to the ground, smashing them at the foot of the mountain'. While there is no clear explanation for the 'horns', it has been suggested that these represent the cornerstones associated with the altar or sanctuary of God. In this sense Moses is seeing and judging the world from God's holy place.

Public Life

From 1514 to *c.* 1536, the year when he returned to the Sistine Chapel to paint *The Last Judgement*, Michelangelo embarked on a series of aborted ventures, returns to the Carrara quarries for stone for his Pope

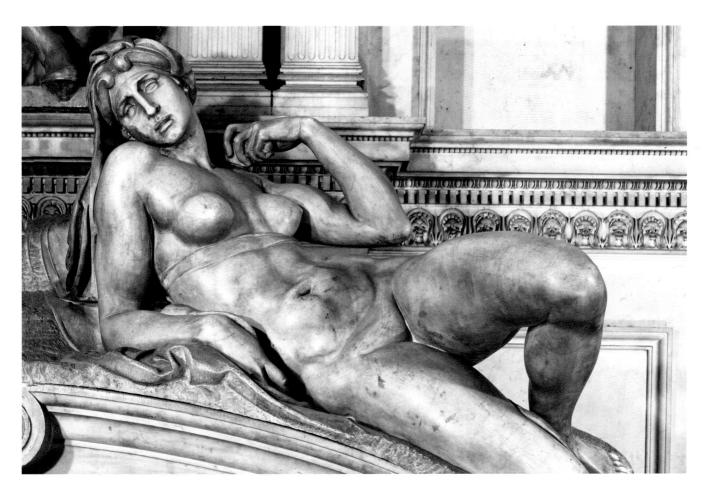

Julius tomb, and other commissions in Florence for the Medici Chapel and the Biblioteca Laurenziana (begun in 1523).

During 1527–28 Florence believed it was about to be attacked by the papal army and Michelangelo had to abandon his work and assume the position of Chief of Fortifications. A year later he fled Florence and was declared a traitor. He then returned when the imperial forces took the city but was granted immunity by Pope Clement if he continued to work on the Medici Chapel figures, two of which he finished in 1531, *Night* (*see* left figure, page 11) and *Dawn* (*see* above).

In 1532 he returned to Rome to strike a deal with the heirs of Pope Julius for a smaller tomb – they never believed his honesty regarding the amount of money he had received while the pope was alive.

A Personal Matter

In 1532 Michelangelo met Tommaso de'Cavalieri (1509–87), a man with whom he would spend most of the rest of his life in, at least, a Platonic partnership and to whom he dedicated many poems and paintings. In the first publications of the poems their homoerotic sexuality was censored.

Not so in this following passage addressed to Tommaso:

Why should I seek to ease intense desire
With still more tears and windy words of grief?
If only chains and bands can make me blest,
No marvel if alone and naked I go
An armed Cavalieri's captive and slave confessed.

A clear and unbiased look at the art of Michelangelo and reports of many of his words make it clear that he revered the masculine body and was partial to the virility of masculine companionship, sex and love. There are rumours and reports that many of his models were short-term lovers.

But it would be a mistake to read the past of more than 500 years ago by our current mores, sexual and otherwise. Homoeroticism among youth in the Middle Ages and the Renaissance, not to mention in Antiquity, was commonplace and while it was outlawed this prohibition was rarely enforced – organized religion and the state needed families to have allies and heirs, to build communities that were not based on desire and passion alone. No doubt another type of society could have been invented, but that is neither here nor there. It can be argued that to a much greater degree than today, for better or for worse, sexuality in the Renaissance was as close to a private matter as is humanly and socially possible.

Vittoria Colonna

From about 1541, perhaps worried about the fate of his soul in heaven, Michelangelo struck up a close relationship with Vittoria Colonna (1492–1547) until her death, and dedicated many religious drawings and mystical paintings to her. Here is an extract from a poem written by Michelangelo (and translated by H.W. Longfellow (1807–82), entitled 'To Vittoria Colonna':

When the prime mover of many sighs
Heaven took through death from out her earthly place,
Nature, that never made so fair a face,
Remained ashamed, and tears were in all eyes.

It is likely that the pious widow and Michelangelo were not sexually intimate, but then, who knows, and what does it matter? Clearly their love for each other was strong and the inspiration derived from their relationship, like Michelangelo's art, surpassed all material and physical boundaries. Religion, humanism, art, intellect and love were matters of the spirit and not merely of body and stone.

The End of the Man

Without denying the importance of the many works Michelangelo accomplished or left unfinished, the three major works Michelangelo left to posterity were *The Last Judgement* at the Sistine Chapel, finished in 1541; *Moses*, finished in 1545 as part of the Pope Julius II tomb in San Pietro in Vincoli, Rome; and, following his appointment as Head Architect of St Peter's Basilica in 1547, the crown jewel of the Vatican City, the dome of which he completed with an assistant in 1561.

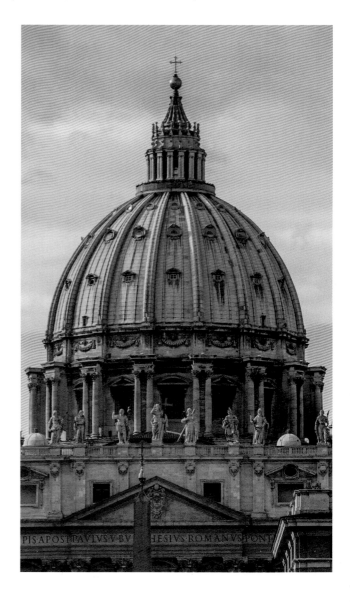

On 18 February 1564, in Rome, a few days after having come down with a fever while working on his unfinished *Rondanini Pietà* (*see* right), now at the Sforza Castle Museum in Milan, Michelangelo the Genius, the Divine, died. His work, of course, lives on. The pope wished to see him buried in St Peter's but his nephew and heir, Leonardo, took his body back to Florence where it was buried in the church of Santa Croce. Well over a hundred artists, artisans and patrons attended his funeral.

'A Lovely Strangeness'

Many words have been said and written about Michelangelo's strength and bitterness, about his flights of temper and anger, about his intolerance of those inferior and sometimes even equal to him. He could argue with popes and patrons as quickly as with anyone else who opposed his desires. He could work until starvation and watch the clothes fall off his back. His physical persona seemed to have embodied a sort of dark and gloomy sadness.

And yet to look at one of his works is to be struck with an unbelievable awe, a sight that one would find hard to explain at the sight of its creator. Perhaps that is one reason why he troubles us so as a man, and why his works seem destined to live forever. The fact is, we know little of the inner man himself – he was an unreliable narrator to others and most likely a true mystery to himself. Still, it cannot be repeated too often: the work is still there, as if it had just been unveiled yesterday.

Walter Pater, who had a keen sympathy and understanding for the man and his art, said: 'A certain strangeness, something of the blossoming of the aloe, is indeed an element in all true works of art: that they shall excite or surprise us is indispensable. But that they shall give pleasure and exert a charm over us is indispensable too; and this strangeness must be sweet also – a lovely strangeness. And to the true admirers of Michelangelo this is the true type of the Michelangelesque – sweetness and strength, pleasure with surprise, an energy of conception which seems at every moment about to break through all the conditions of comely form, recovering, touch by touch, a loveliness found usually only in the simplest natural things – *ex forti dulcedo*.'

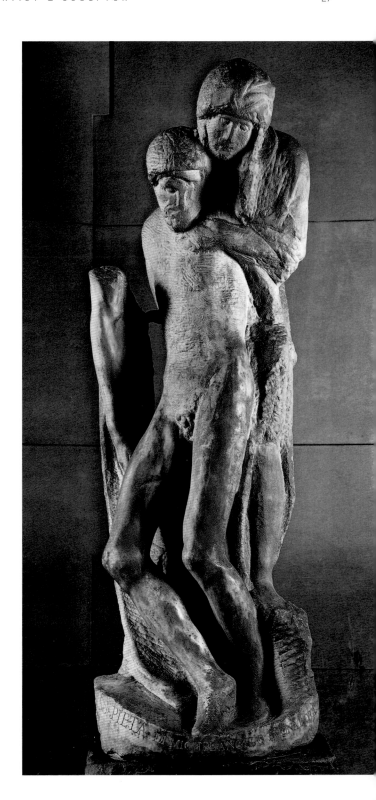

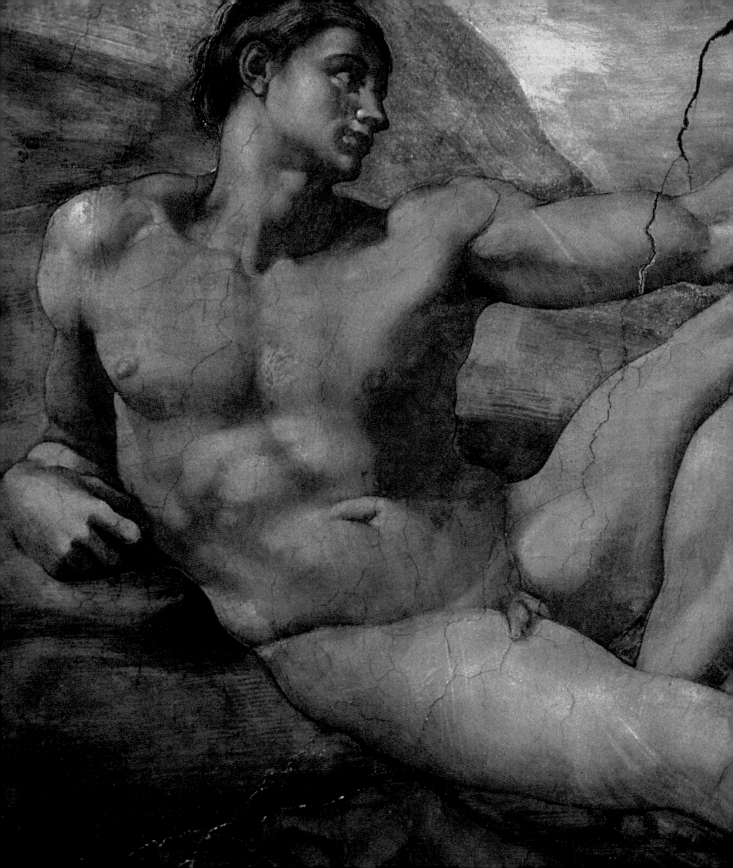

Sistine Ceiling: Genesis Panels

A renowned sculptor, though still an unknown entity as a painter, Michelangelo received the commission to paint over 300 figures on the Sistine Chapel ceiling. The panels down the middle illustrate episodes from the Book of Genesis.

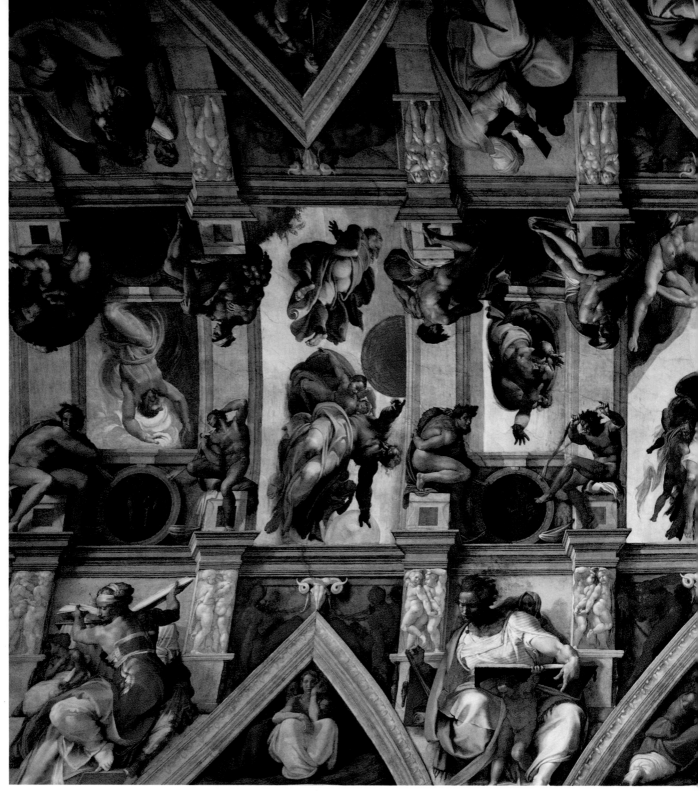

The Sistine Chapel ceiling and lunettes, 1508–12
Fresco, 4050 x 1400 cm (1594½ x 551 in)
• Vatican Museums and Galleries, Vatican City

The nine panels of the central column narrate the story of Genesis, from *The Separation of Light from Darkness* (*see* page 32) to *The Drunkeness of Noah* (*see* page 47). The side columns feature sibyls and prophets announcing the Coming of Christ.

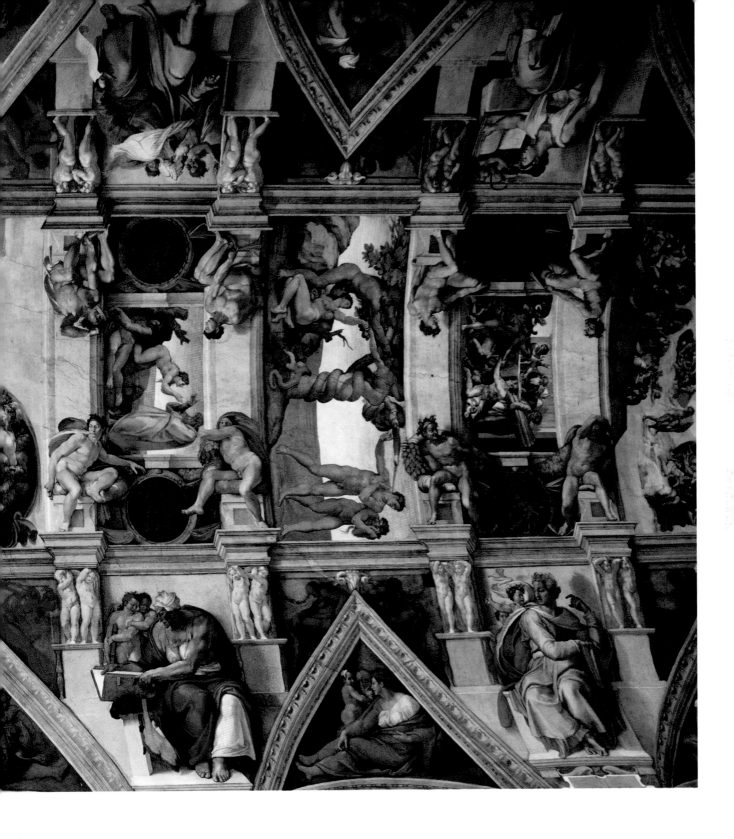

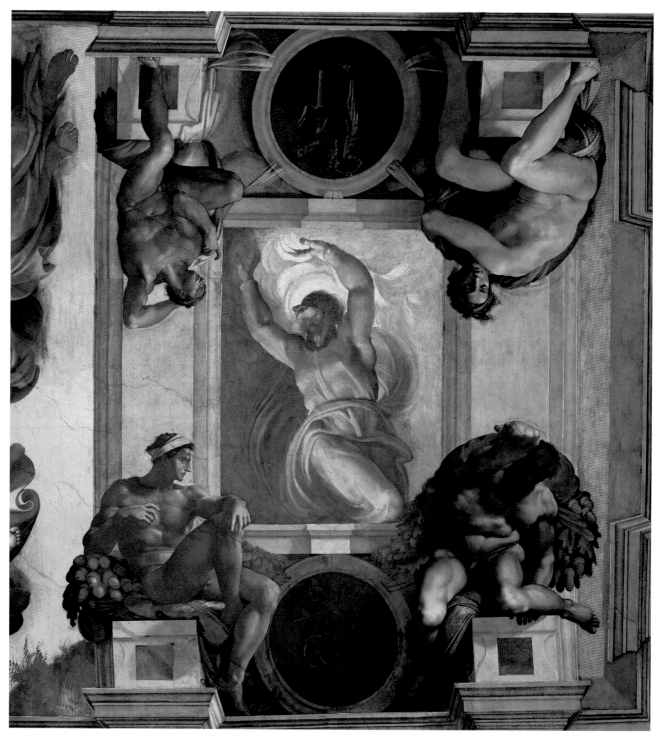

The Separation of Light from Darkness, *c.* 1511–12
Fresco • Vatican Museums and Galleries, Vatican City

The hands of The Maker leave visceral traces in their wake, that make a moving force in what before had been inchoate form. As the light brightens so do the features of the head and hands.

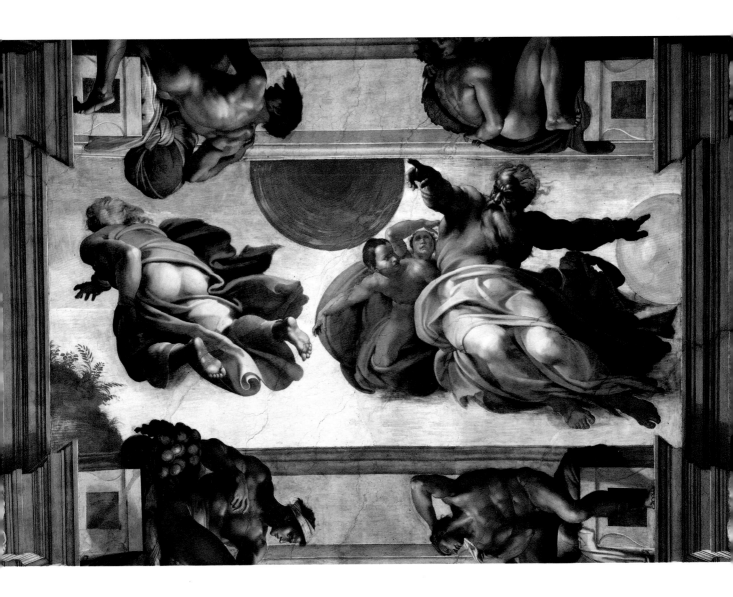

The Creation of the Plants, Sun and Moon, _c._ 1511–12
Fresco • Vatican Museums and Galleries, Vatican City

The lights in the firmament divided the day from the night and stood for signs and for seasons, and for days and for years. One senses the musical gestures of the conductor striking the first notes of the music of the spheres.

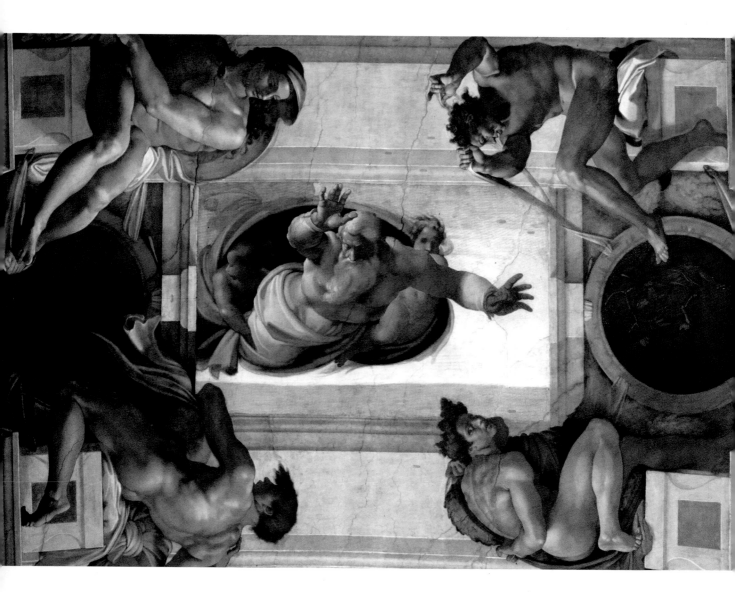

The Separation of Earth from the Waters, *c.* 1511–12
Fresco • Vatican Museums and Galleries, Vatican City

God appears to be emerging from a maelstrom both rising and falling, gaining a first preview of His terrestrial domain. Now the four basic elements of life are at play.

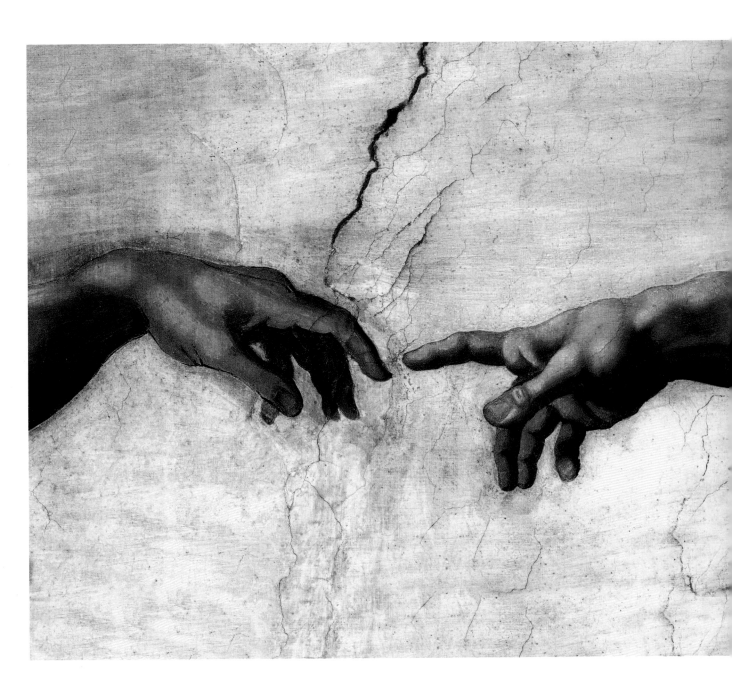

The Hands, detail from The Creation of Adam, *c.* **1511–12**
Fresco • Vatican Museums and Galleries, Vatican City

Perhaps the most iconic detail from the whole ceiling – the fingers of God and of the first man, who has not yet proved himself worthy of being at one with God, do not actually touch, a signal that a drama is about to unfold. The finger is also said to transmit education.

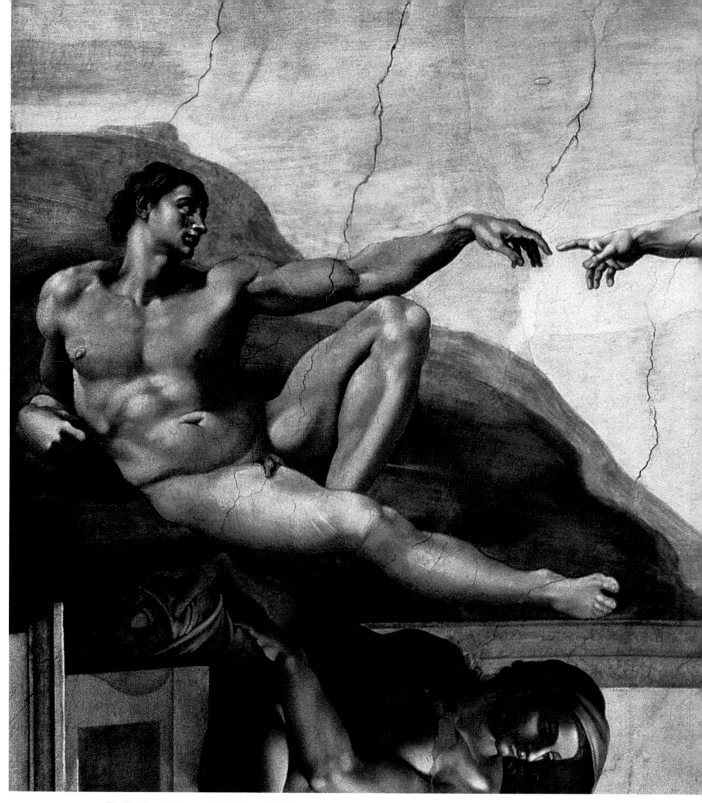

The Creation of Adam, *c.* 1511–12
Fresco • Vatican Museums and Galleries, Vatican City

While known as the creation of the first man, Adam and God seem to want to touch to acknowledge their likeness. This could also be considered the most widely imitated and parodied work of art.

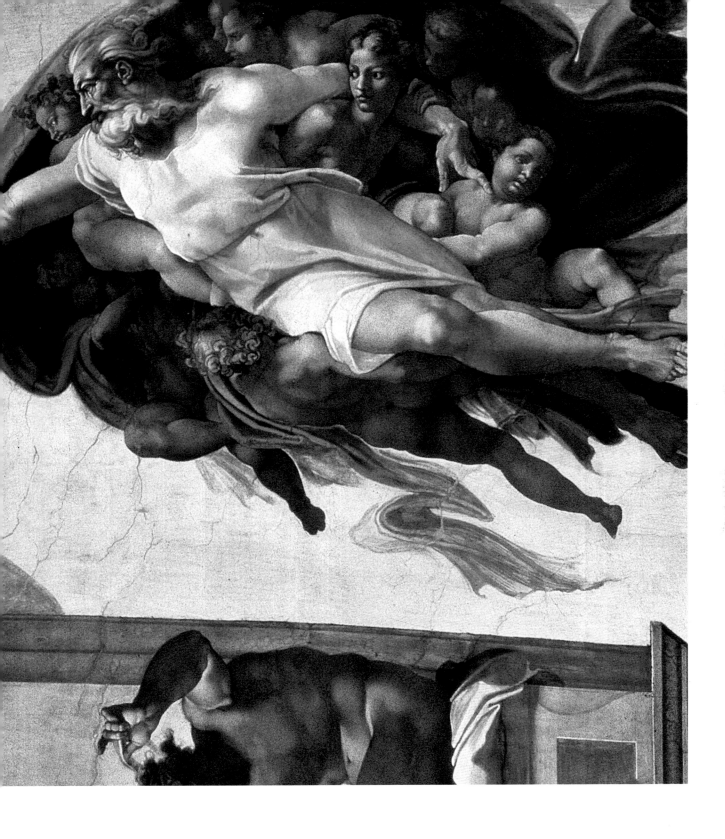

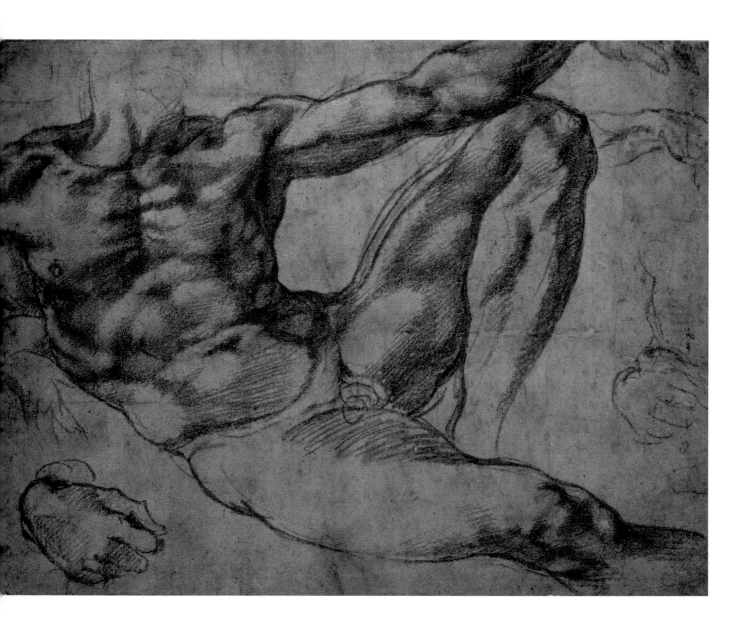

Study for The Creation of Adam, 1511
Red chalk over black chalk, 19 x 25.7 cm (7½ x 10 in)
• British Museum, London

This was drawn from a live model and is the only known surviving study for Adam. It is likely that Michelangelo made several others before completing the full-scale cartoon that was transferred on to the ceiling for the complete tableau.

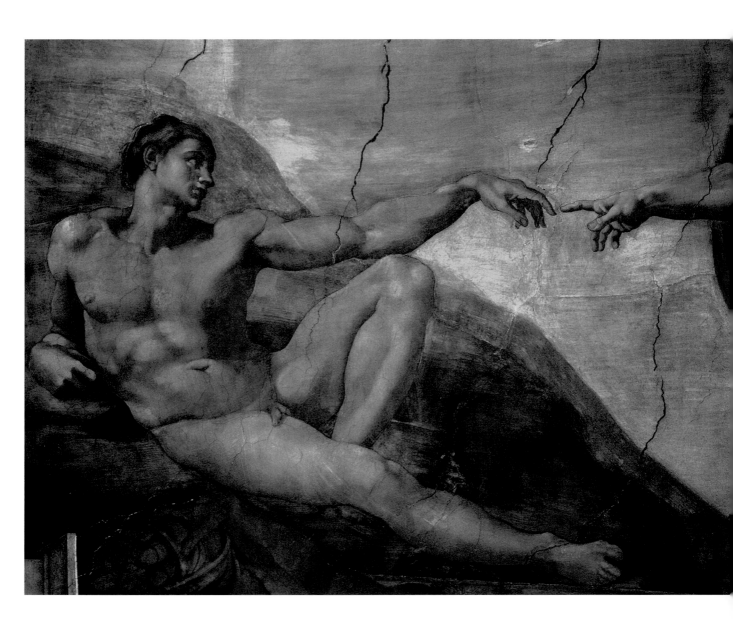

Adam, detail from The Creation of Adam, *c.* 1511–12
Fresco • Vatican Museums and Galleries, Vatican City

Adam's relaxed, reclining figure is more of a melancholy acceptance of his fate than one would expect of an origin scene. Michelangelo has twisted the torso to give a view of man in all his sculpted, magnificent glory.

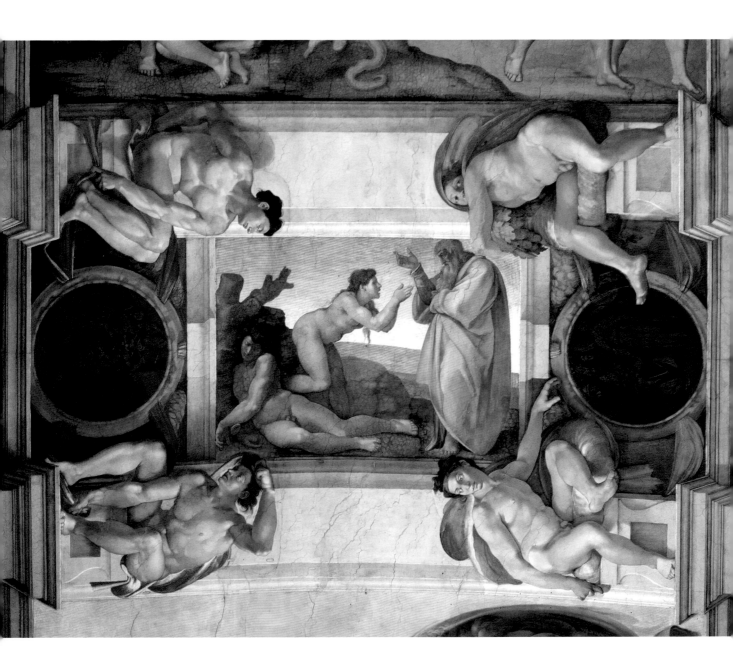

The Creation of Eve, 1511
Fresco • Vatican Museums and Galleries, Vatican City

Eve, in profile, emerging from behind a sleeping Adam, does not display the pain of the biblical narrative. She appears to be both thanking and beseeching God to trust in His need to create a companion for His master creation.

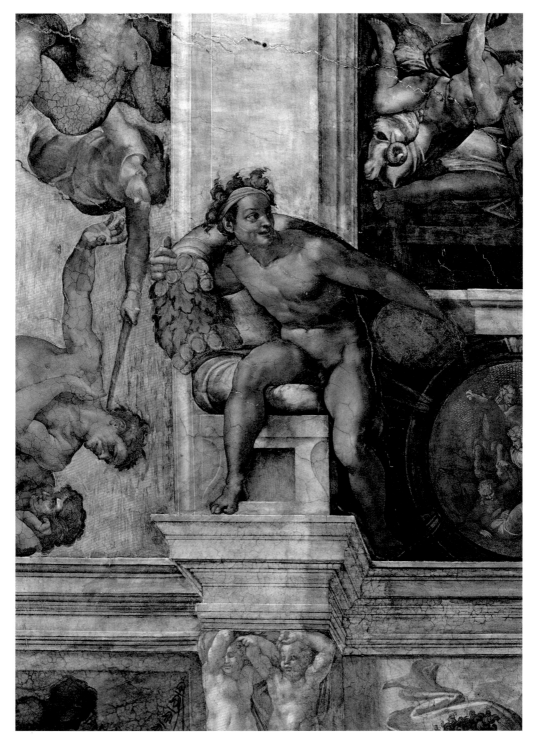

Ignudo from The Expulsion from Paradise, 1508
Fresco • Vatican Museums and Galleries, Vatican City

Michelangelo came up with the term *ignudo* (meaning 'nude' in Italian) to refer to the several figures on frescoes that draw attention away from the main scene and appear both to show his figurative skill and to include witnesses to his creation.

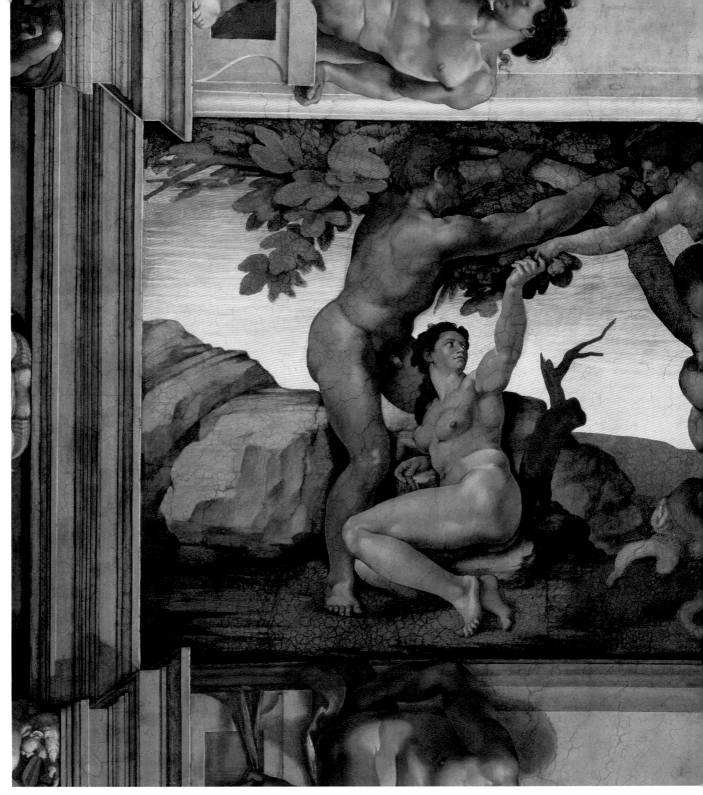

The Fall of Man and the Expulsion from Paradise, 1510
Fresco • Vatican Museums and Galleries, Vatican City

The vibrant colours of the *Expulsion* are another sign of an on-going drama on the stage of this new world. Adam and Eve's transgression to understand the meaning of life is contrasted with the coiling serpent, intertwined with the Tree of Life.

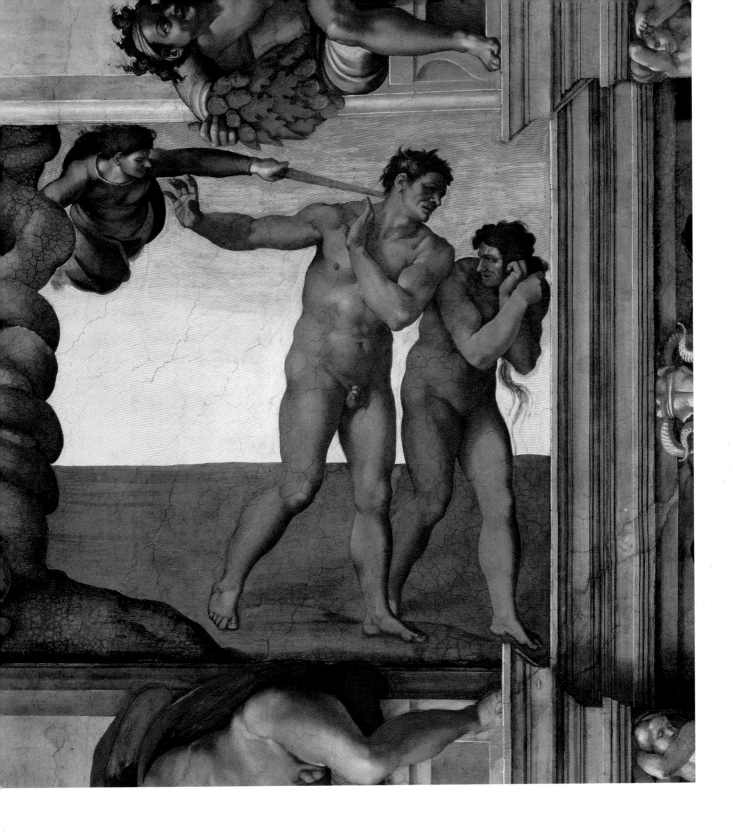

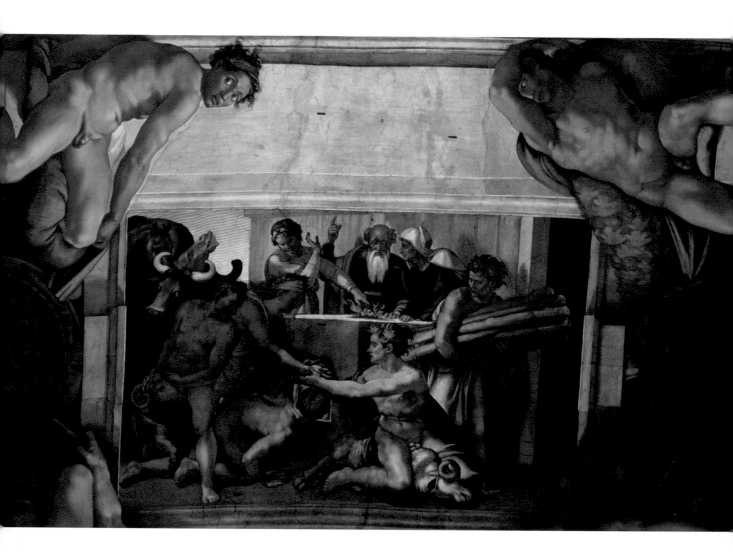

The Sacrifice of Noah, *c.* 1508–11
Fresco • Vatican Museums and Galleries, Vatican City

The Sacrifice of Noah was a ritualistic offering to God. Michelangelo depicts the family of Noah preparing the sacrificial rams and a bullock. The artist used a conventional reading of the Bible and did not interpret the scripture to enhance his breakdown of the narrative on the Sistine ceiling.

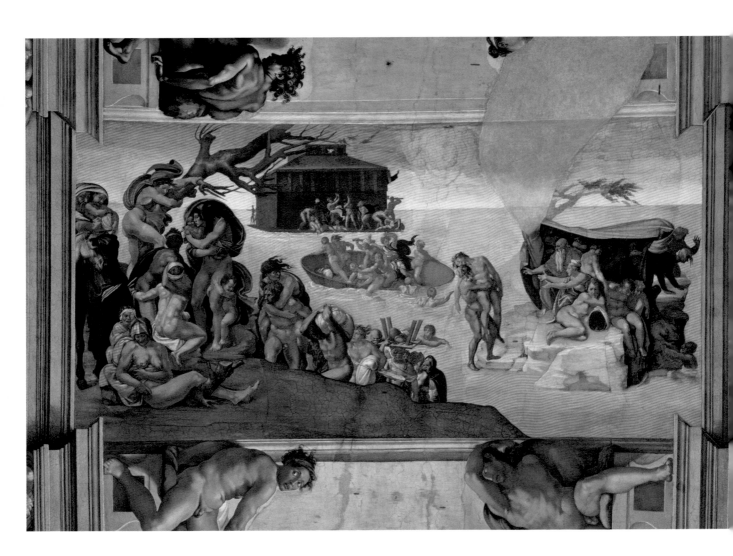

The Flood, *c.* 1508–11
Fresco • Vatican Museums and Galleries, Vatican City

Jesus had very little to say about *The Flood* as such, commenting only that the world went on unperturbed (and unholy) until Noah entered the Ark. Michelangelo's fresco is a colourful portrayal of humankind's nakedness amidst the elements. The fresco was probably the first of his Genesis scenes painted.

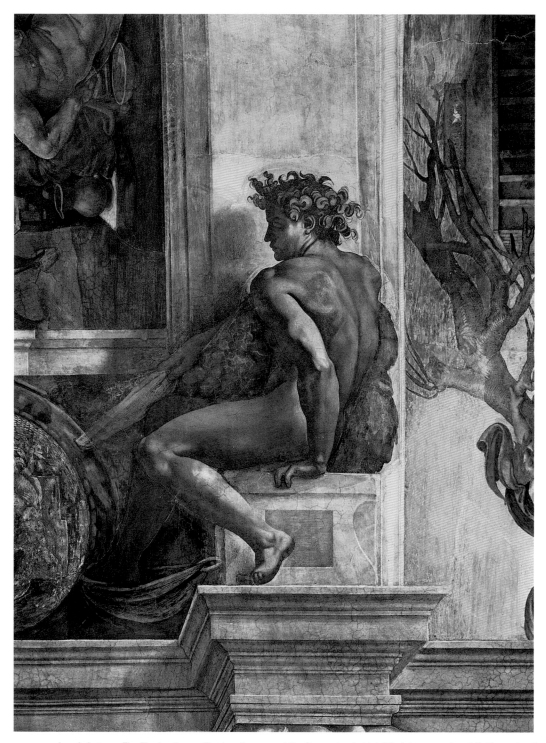

**Ignudo between The Flood and
The Drunkenness of Noah, 1508–12**
Fresco • Vatican Museums and Galleries, Vatican City

The *ignudi* are speculative figures about which little is known and no definitive explanation is likely to be discovered. Coupled with the medallions, they are clearly decorative examples of Michelangelo's detailed figurative and compositional skills as a painter.

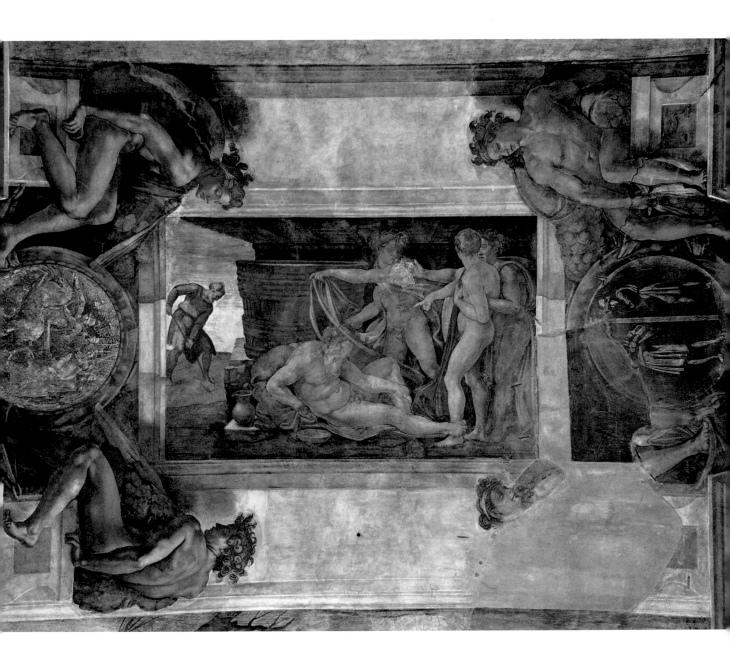

The Drunkenness of Noah, *c.* **1508–11**
Fresco • Vatican Museums and Galleries, Vatican City

No one, including his sons, seems particularly worried or ashamed of Noah's drunkenness. His body, striking a similar pose to that of Adam in *The Creation*, is simply covered and observed as being one part of God's vast nature and a reminder of his sinful place in it.

Sistine Ceiling: Prophets, Sibyls & Ancestors

The paintings of the Sistine were greatly, if jealously, admired at the time of their painting. Surrounding the Genesis panels are depictions of Prophets of Israel and Sibyls of the Classical world, ancestors of Christ and narratives of the People of Israel.

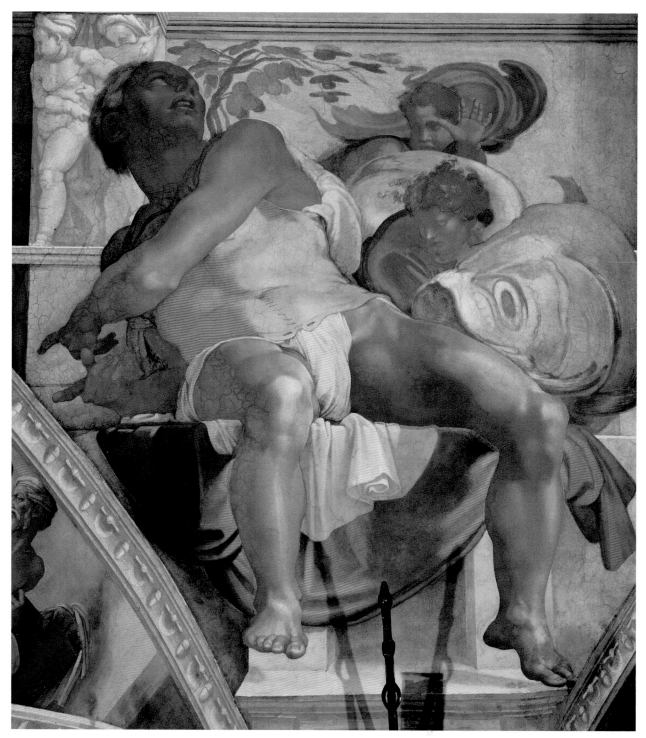

Jonah, 1508–12
Fresco • Vatican Museums and Galleries, Vatican City

The pendentives along the sides and ends of the ceiling, outside the Genesis panels, depict 12 male prophets and female Sibyls. Michelangelo's depiction of Jonah, who famously gets swallowed by a big fish – or whale – and prays to God for deliverance, is directly above the altar.

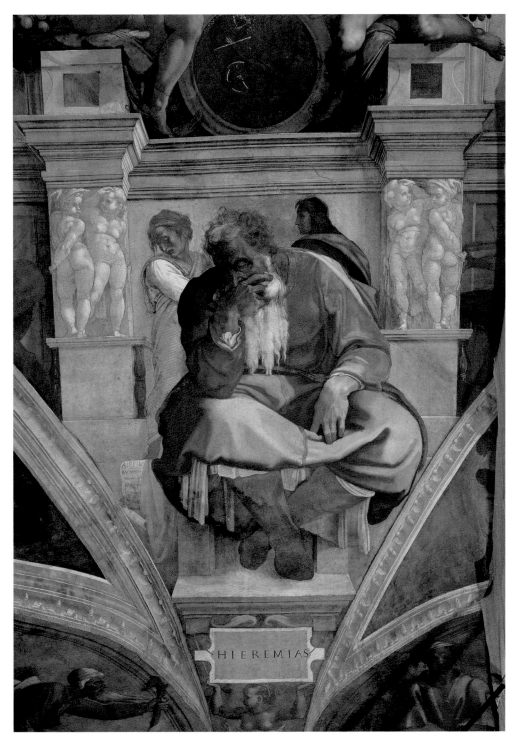

Jeremiah, 1508–12
Fresco • Vatican Museums and Galleries, Vatican City

Jeremiah is another major Old Testament prophet painted by Michelangelo. Jeremiah's passion against idolatry and fight against corrupt political regimes led to his exile to Egypt, where he was assassinated. Fortunately, Michelangelo, on a similar life path, was not assassinated.

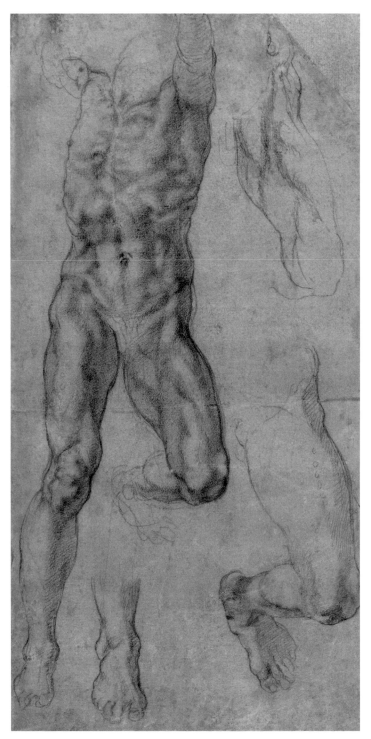

Studies for Haman, 1511–12
Red chalk on paper, 40.6 x 20.7 cm (16 x 8 in)
• British Museum, London

Michelangelo appeared to use a live model for this drawing. Haman, who had tried to instigate a campaign against the Jews, was hanged for his deeds. The study is notable also for its overstretched limbs, revealing Michelangelo's attention to musculature detail.

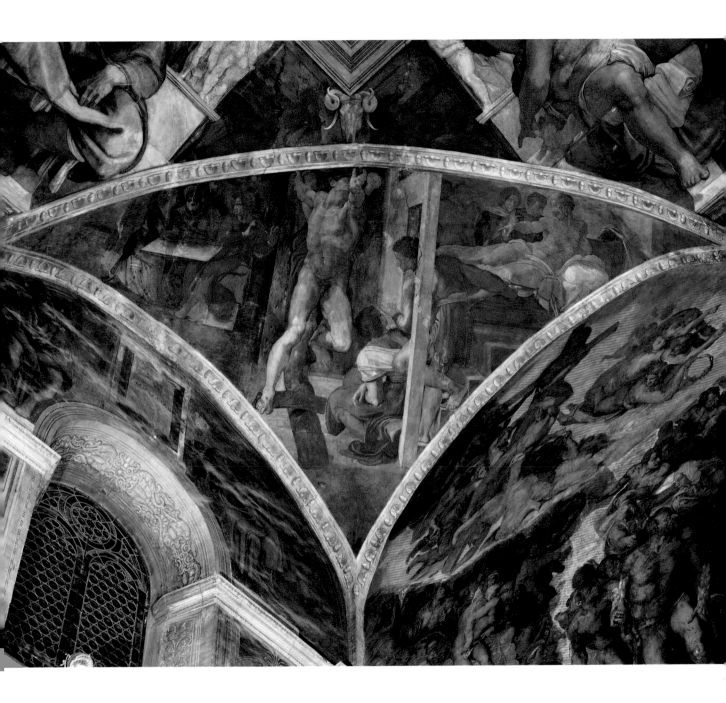

The Punishment of Haman corner pendentive, 1508–12
Fresco • Vatican Museums and Galleries, Vatican City

Haman is punished for trying to convince the King of Persia that he should slaughter Mordecai and the Jews in Persia. Queen Esther, herself a Jew, gets word of the plot, offers her life instead, and the king is outraged at Haman who tried to usurp his power. In the end, Haman is hanged in place of Mordecai.

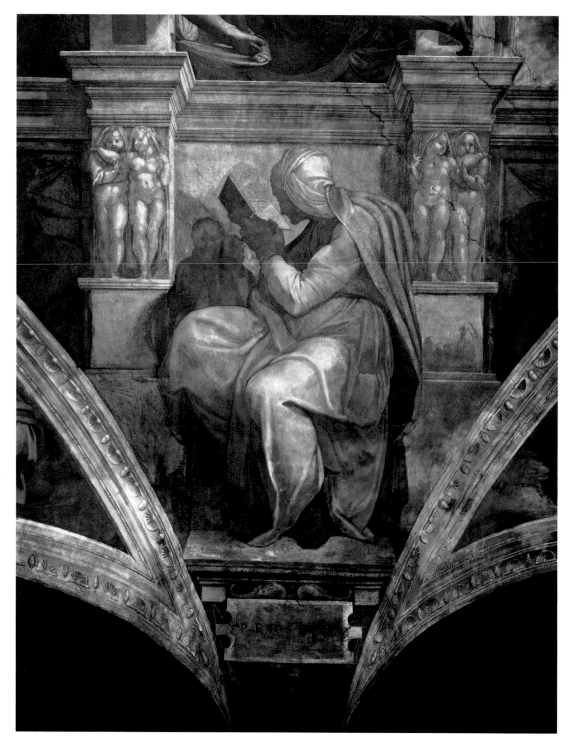

Persian Sibyl, 1508–12
Fresco • Vatican Museums and Galleries, Vatican City

The Persian Sibyl is one of the more beautiful 'details' of the Sistine Chapel ceiling and depicts the sibyl reading from the Old Testament scriptures, no doubt foretelling of the coming of the prophet. The sibyls were signs of conciliation between pagan and Christian cultures.

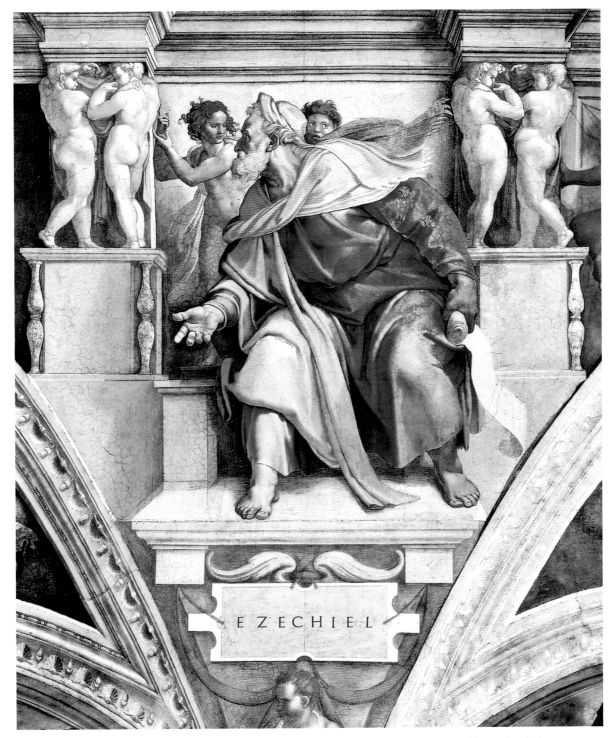

Ezekiel, 1510
Fresco • Vatican Museums and Galleries, Vatican City

Ezekiel is a mysterious prophet of the Old Testament whose visions and oracles have grown in popularity over time. Ezekiel warns us of the end of nations and of the last days. He is one of the earliest prophets to have had visions of God appearing in man's form.

Ozias spandrel, 1508–12
Fresco • Vatican Museums and Galleries, Vatican City

These triangular spandrels, each depicting a family, appear to have been used by Michelangelo as a quiet supporting element of the busy Sistine ceiling. Most of the figures are unknown for certain (the spandrels are named for the lunette below) but all appear to be waiting for the Coming of Christ.

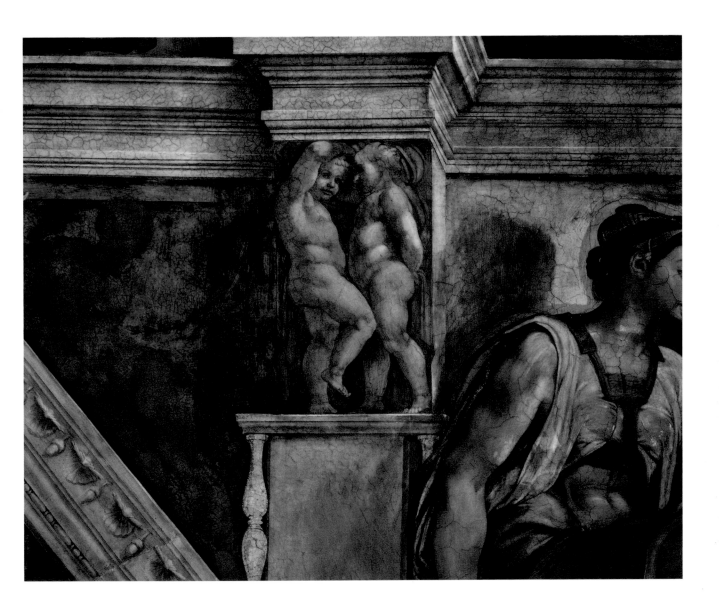

Putti to the left of the Erythraean Sibyl, 1508–12
Fresco • Vatican Museums and Galleries, Vatican City

The *putti* or naked children, often cherubs or cupids, were numerous throughout the ceiling, giving relief to the two-dimensional moulding and keeping the viewers moving from panel to panel.

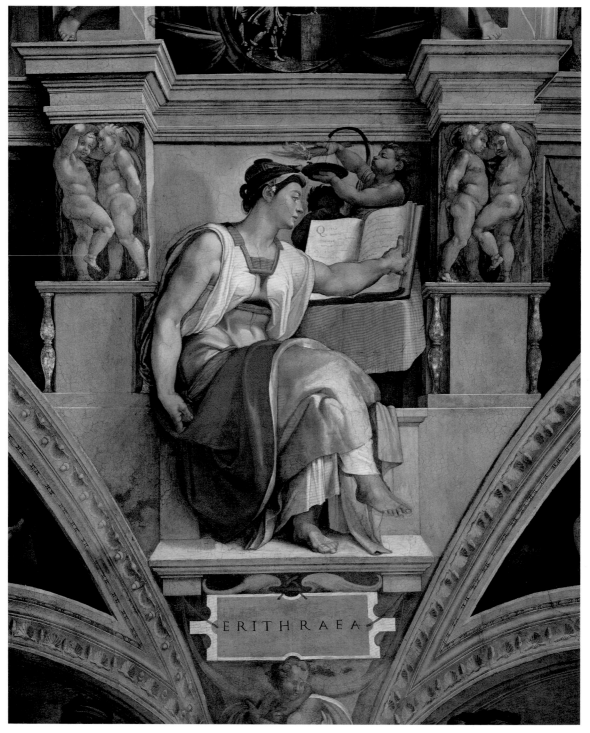

Erythraean Sibyl, 1510
Fresco • Vatican Museums and Galleries, Vatican City

Classical Antiquity is the most striking link between Michelangelo and this prophetess, who kept watch over the Apollonian oracle at Erythrae where Leto and Zeus gave birth to Apollo and Artemis.

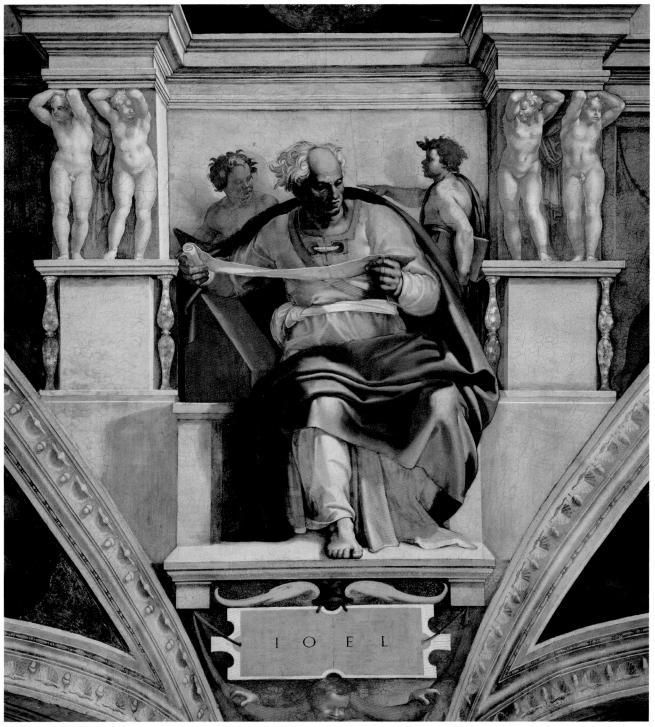

Joel, 1508–12
Fresco • Vatican Museums and Galleries, Vatican City

Joel prophesies the Coming of a wrathful Lord that will change the hedonistic ways of the land and strike down the corrupt rulers of the temple. This was one of the first prophets to be painted on the ceiling, appearing beneath *The Drunkenness of Noah* panel (*see* page 47).

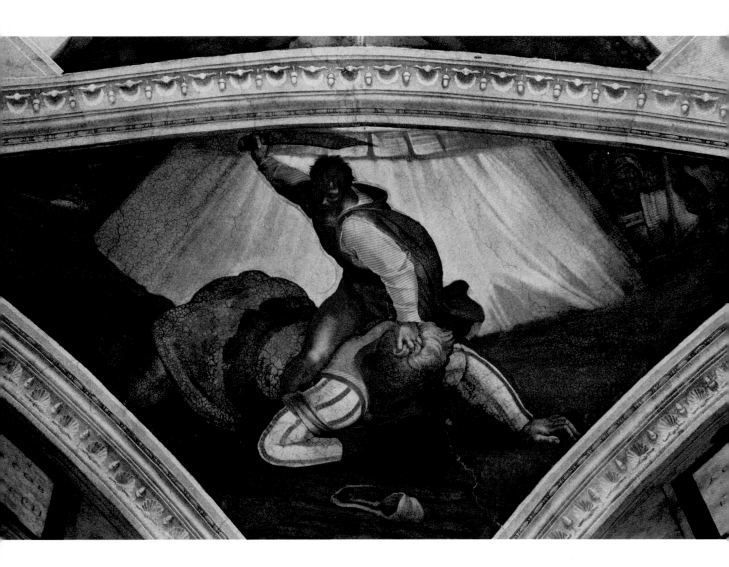

David and Goliath corner pendentive, 1509
Fresco • Vatican Museums and Galleries, Vatican City

Michelangelo graphically illustrates the battle between David and Goliath as told in the Book of Samuel. Again, his use of colour and light give a highly staged effect to the drama. Like the statue of *David*, the intention to behead Goliath is enough to communicate the violence of the narrative.

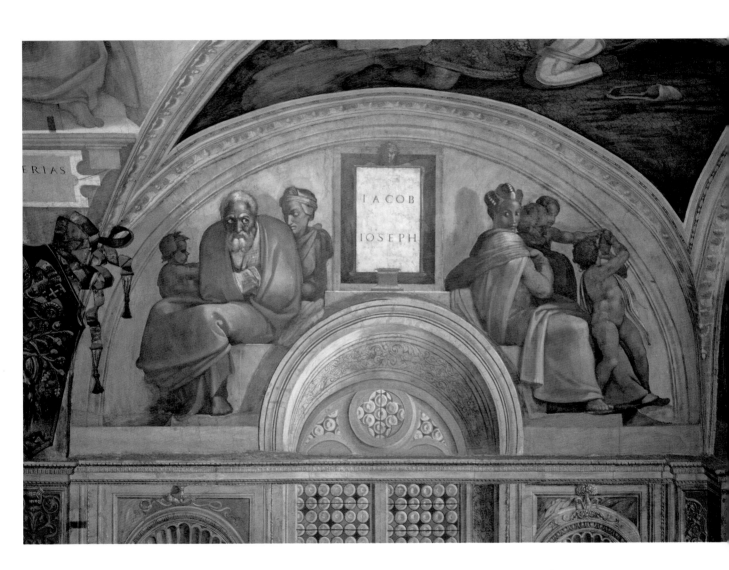

Jacob and Joseph lunette, 1508–12
Fresco • Vatican Museums and Galleries, Vatican City

Joseph is the personification of faith. His fall and rise in Egypt, having been exiled there by his jealous brothers, is common to Christianity, Judaism and Islam. In this depiction, one senses disquiet in the face of the foreboding arrival of Christ.

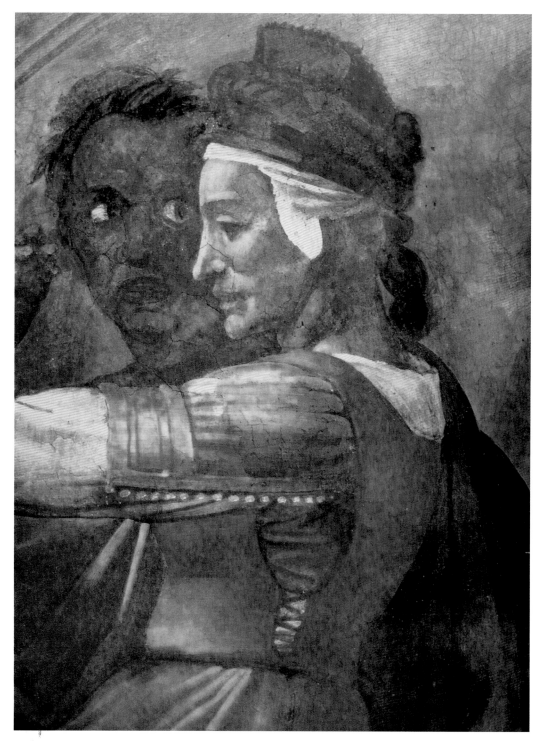

Eleazar and Mathan lunette, 1508–12
Fresco • Vatican Museums and Galleries, Vatican City

Eleazar also is a great bearer of faith, having served and helped Moses since early childhood. In this detail he is depicted with his wife (the whole lunette also portrays their child). All appear humble, the wife somewhat subservient and the child obedient, shielded by Eleazar's strong and pensive seated posture.

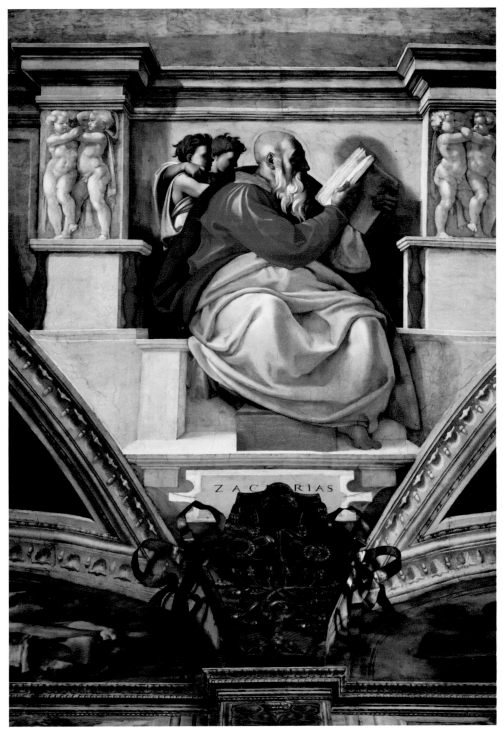

Zacharias, 1508–12
Fresco • Vatican Museums and Galleries, Vatican City

Zacharias appears to be another of Michelangelo's prophets disturbed by the hedonistic ways of contemporary Florentines. His Lord chastises the citizens for taking possession of his words and statues, and commands them to turn from their evil ways.

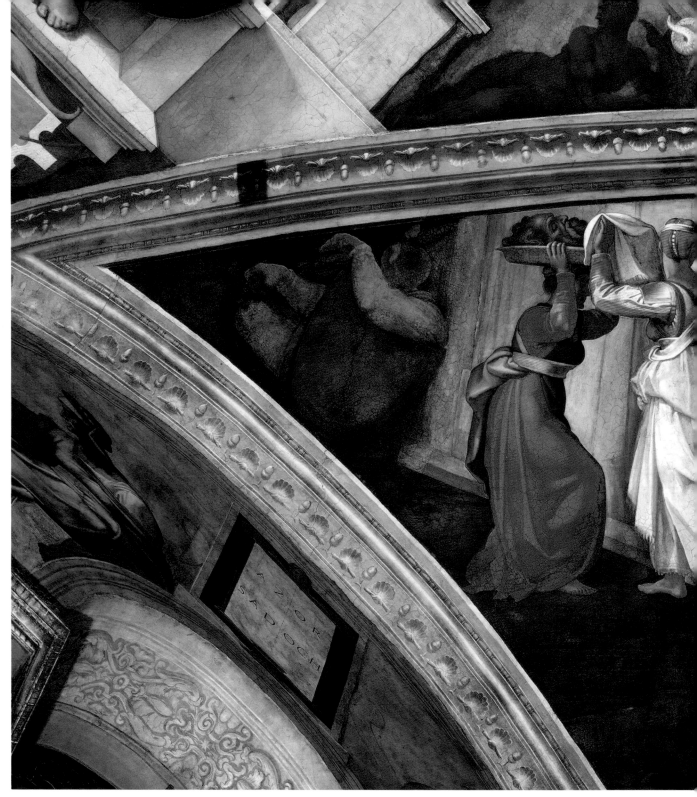

Judith and Holofernes corner pendentive, *c.* 1509

Fresco • Vatican Museums and Galleries, Vatican City

While Judith represents the Jewish struggle for existence in the Near East and is frequently seen bearing the decapitated head of Holofernes, the Assyrian general, Michelangelo's female figures are uncharacteristically feminine and the colours full of light.

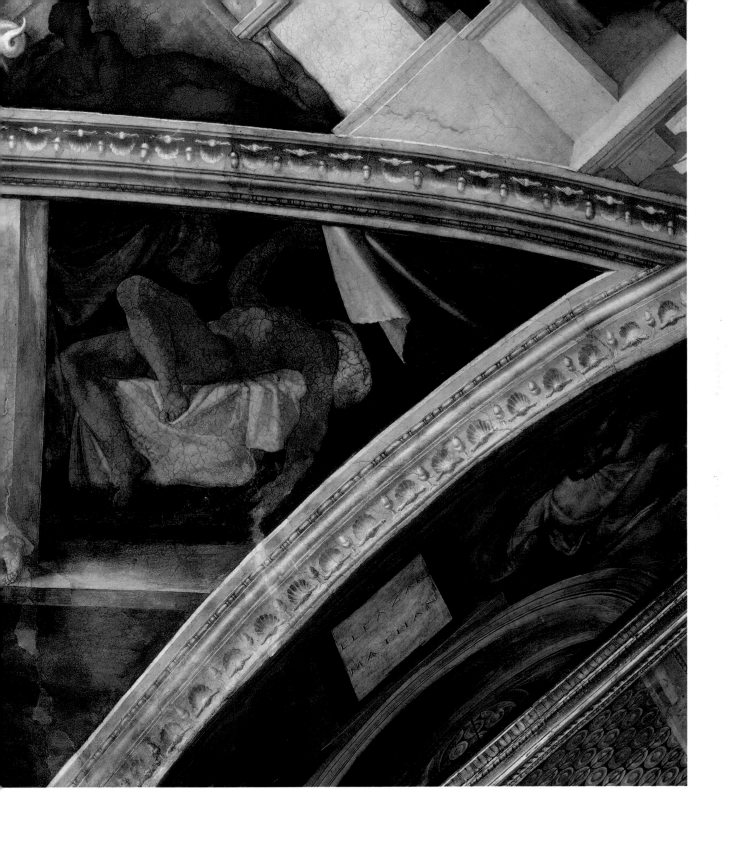

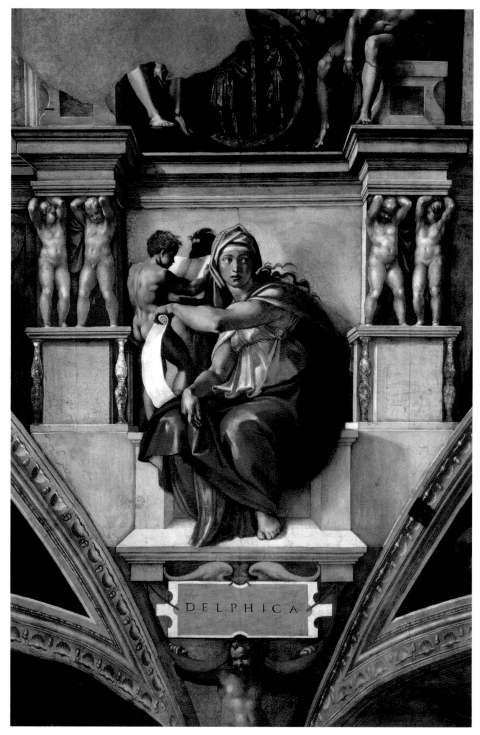

Delphic Sibyl, 1508–12
Fresco • Vatican Museums and Galleries, Vatican City

Unlike most of the other Sibyls, who are twisted away from the viewer, this ancient Sibyl is turned to face us. The contour of the body shows in the painter's skilful play of drapery and colour as opposed to its muscular frame.

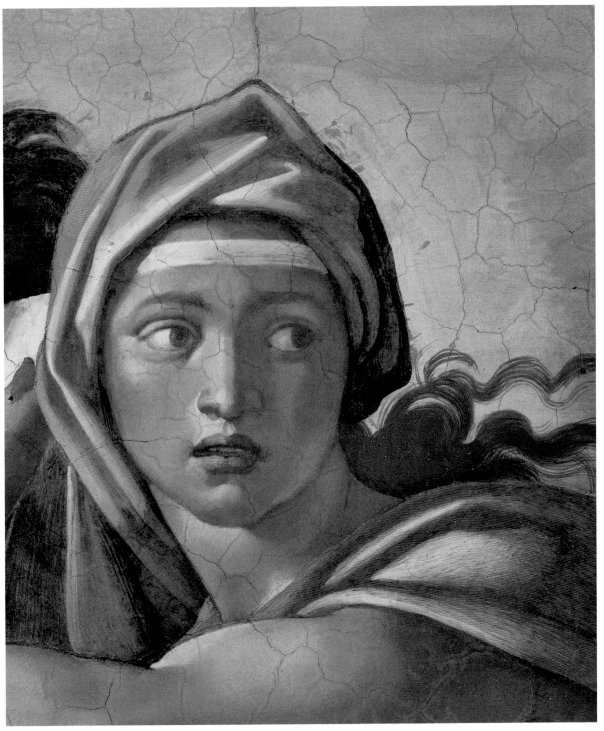

Head detail of the Delphic Sibyl, 1508–12
Fresco • Vatican Museums and Galleries, Vatican City

If ever proof was needed that Michelangelo could depict seductive feminine beauty in paint as well as in sculpture, the soft round face, wide eyes and small parted lips of the Delphic Sibyl should put all doubts to rest.

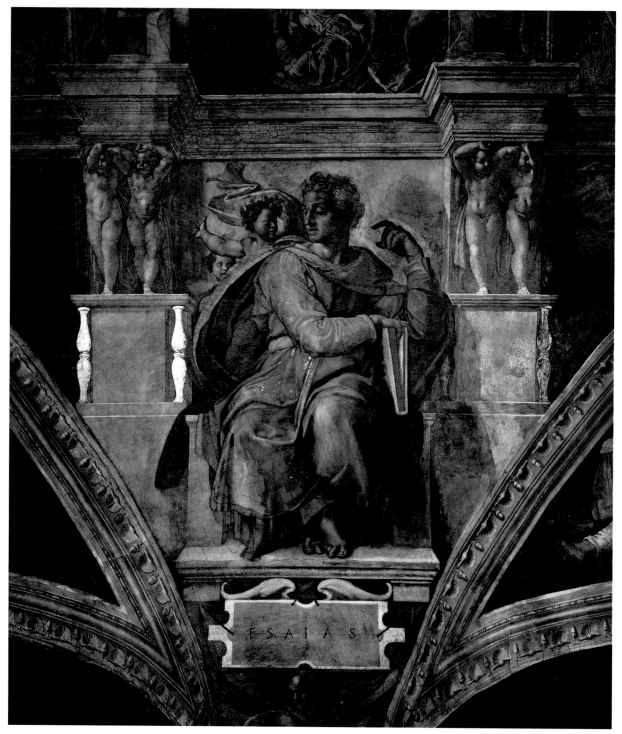

Isaiah, 1508–12
Fresco • Vatican Museums and Galleries, Vatican City

The prophet Isaiah appears in bright and much more feminine colours than most of his male counterparts, and the graceful sweep of his draping robes seems to give sound to the conversation he is having with the *putto* standing behind his right shoulder.

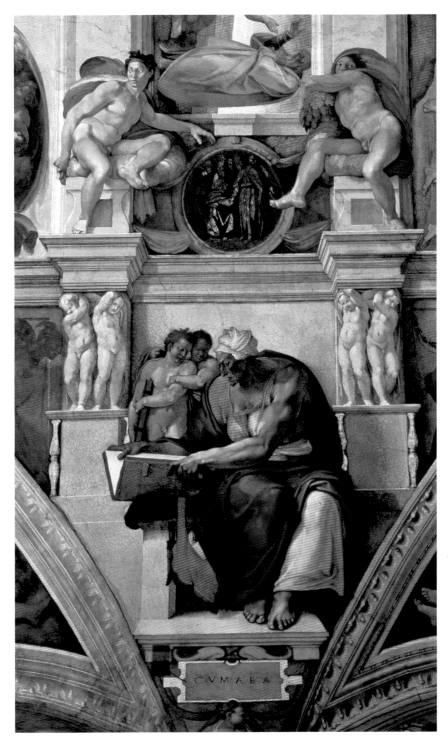

Cumean Sibyl, 1510
Fresco • Vatican Museums and Galleries, Vatican City

It is said that medieval monks counted 12 sibyls and gave each a separate prophecy and an emblem. The Cumean Sibyl was purported to have said 'God shall be born of a pure virgin and hold converse with sinners'. Her emblem was a cradle.

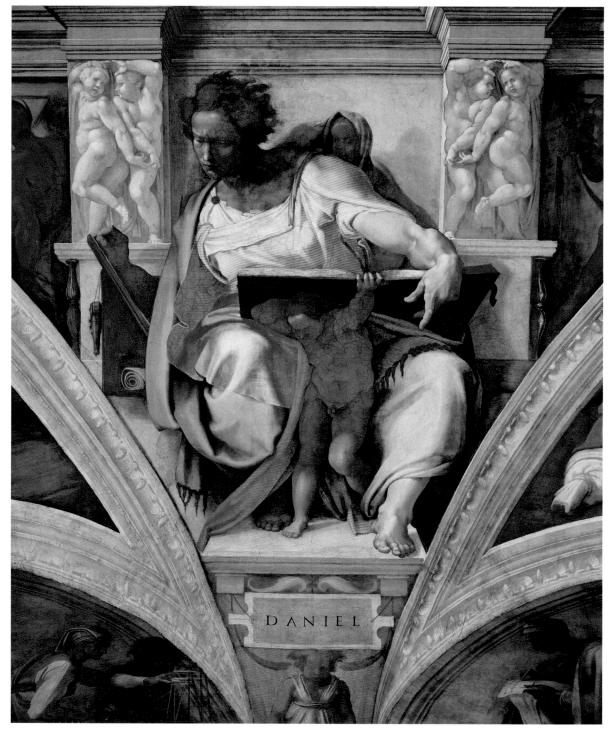

DANIEL

Daniel, 1511
Fresco • Vatican Museums and Galleries, Vatican City

Michelangelo had been painting in the Sistine Chapel for three years when he depicted Daniel, another prophet foretelling the Coming of Christ. What is remarkable is that the scale changes, figures fill active compositional space and the bodies exhibit more grace and movement.

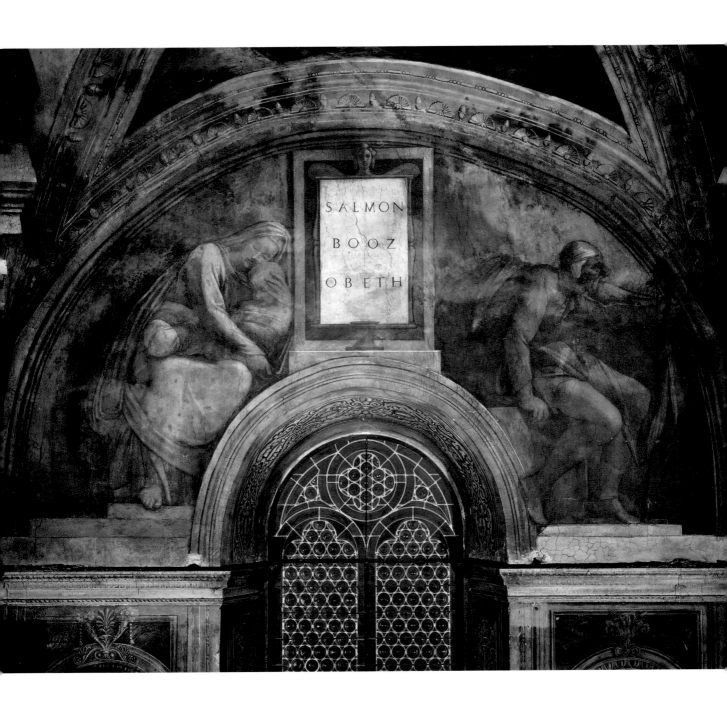

SALMON

BOOZ

OBETH

Salmon, Boaz and Obed lunette, *c.* **1511–12**
Fresco • Vatican Museums and Galleries, Vatican City

One of the ancestors of Christ shown here on the right, poised yet ready to move, seems like so many other figures on the ceiling awaiting the news of the arrival of Christ. Through movement, direction of gaze and bodily positions, Michelangelo creates a vast and silent rumour of the Coming.

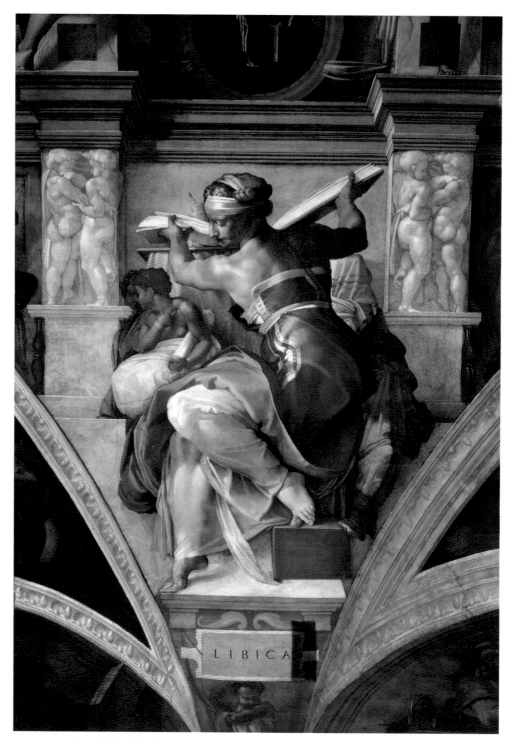

Libyan Sibyl, 1508–12
Fresco • Vatican Museums and Galleries, Vatican City

The study in red chalk has now become fully realized as orange and blue draping robes over sheer white skin. The positions of the various *ignudi* play counterpoint as the sibyl balances her book above her shoulder and her left foot on a sort of pedestal.

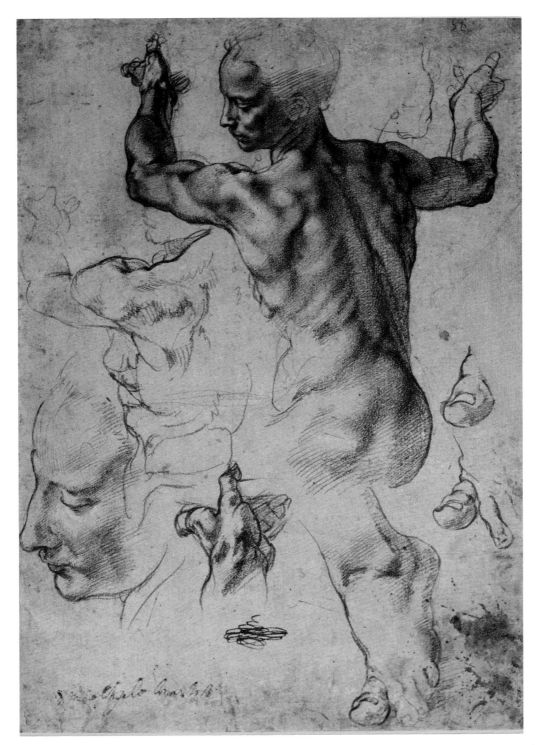

Study for the Libyan Sibyl, *c.* 1508–12
Red chalk on paper, 28.9 x 21.4 cm (11¼ x 8½ in)
• Metropolitan Museum of Art, New York

In this study the sketch of movement is combined with the body that moves Michelangelo away from stone and on to the flat surface of the frescoed ceiling. Again, the body has a masculine edge to it, but the twisting of the back, a spiralling upwards, attains the balance of a dance.

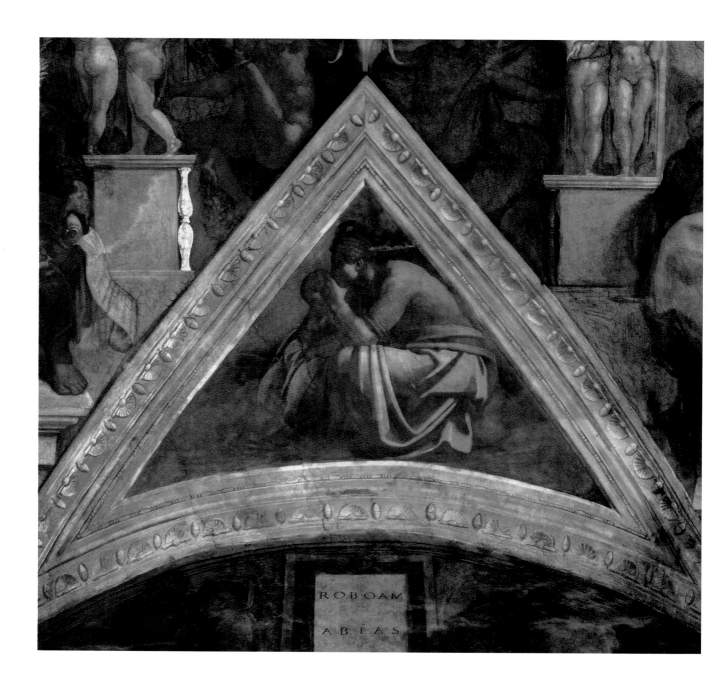

Rehoboam spandrel, 1508–12
Fresco • Vatican Museums and Galleries, Vatican City

Again, Michelangelo uses families waiting for the Coming of Christ as pillars to the painting on the Sistine Chapel ceiling. As with most pendentives and lunettes the mouldings and architectural elements are successfully rendered in two dimensions.

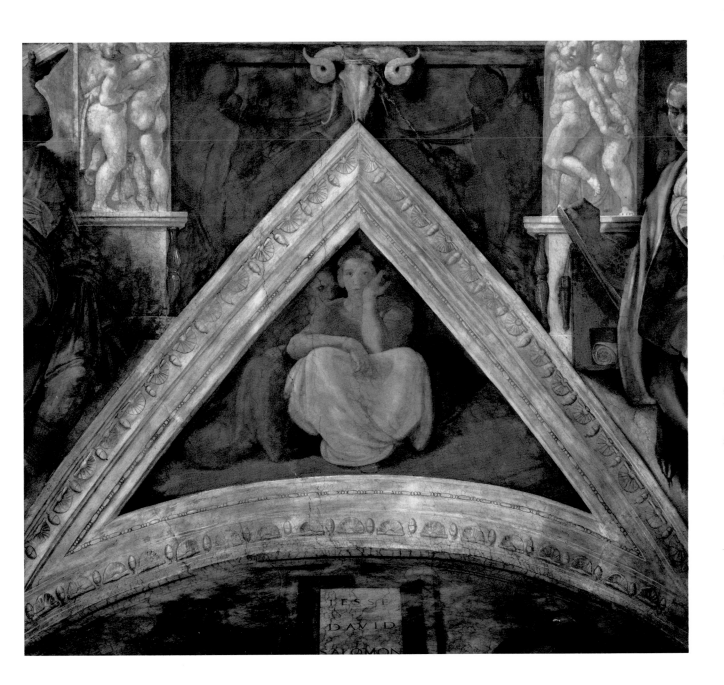

Jesse spandrel, 1508–12
Fresco • Vatican Museums and Galleries, Vatican City

Yet another soft feminine figure who most likely represents Mary, Mother of Christ, sits in the spandrel with a figure watching behind her. Her expressionless face is nevertheless not without emotion – she appears to know who is coming.

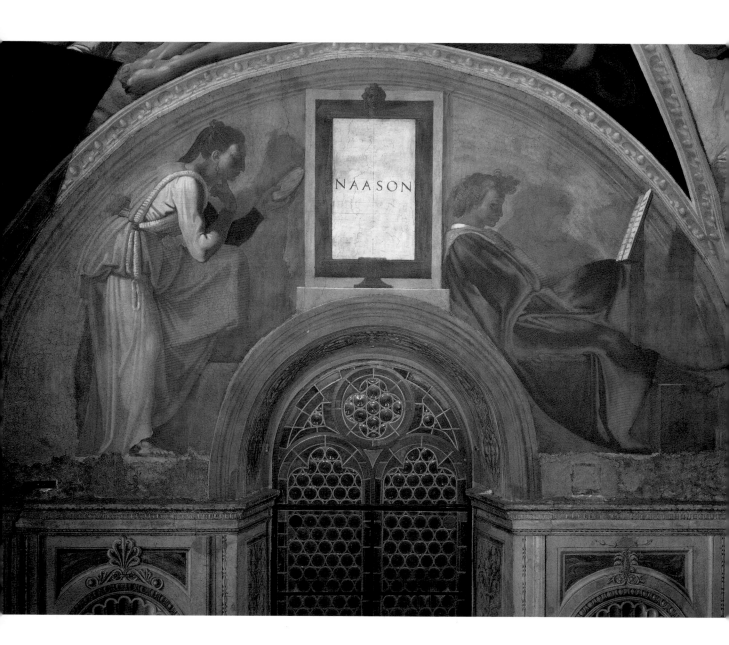

Naason lunette, 1508–12
Fresco • Vatican Museums and Galleries, Vatican City

The composition of the Naason features a contrast between the contemplative attendant on the right looking out, and the female figure with a vanity – a mirror – that could have been found in one of the frequent 'Bonfire of the Vanities' around that period.

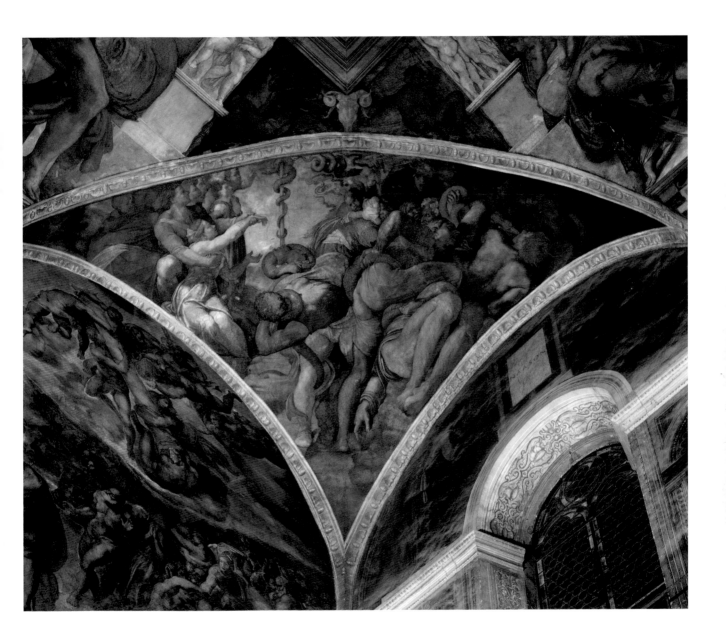

The Brazen Serpent corner pendentive, 1511
Fresco • Vatican Museums and Galleries, Vatican City

The pendentives at the sides of Jonah (*see also The Punishment of Haman*, page 53) are typical of Michelangelo's skilful use of foreshortening. Here we see the Israelites, having spoken out against Moses and God, being punished with a plague of poisonous snakes.

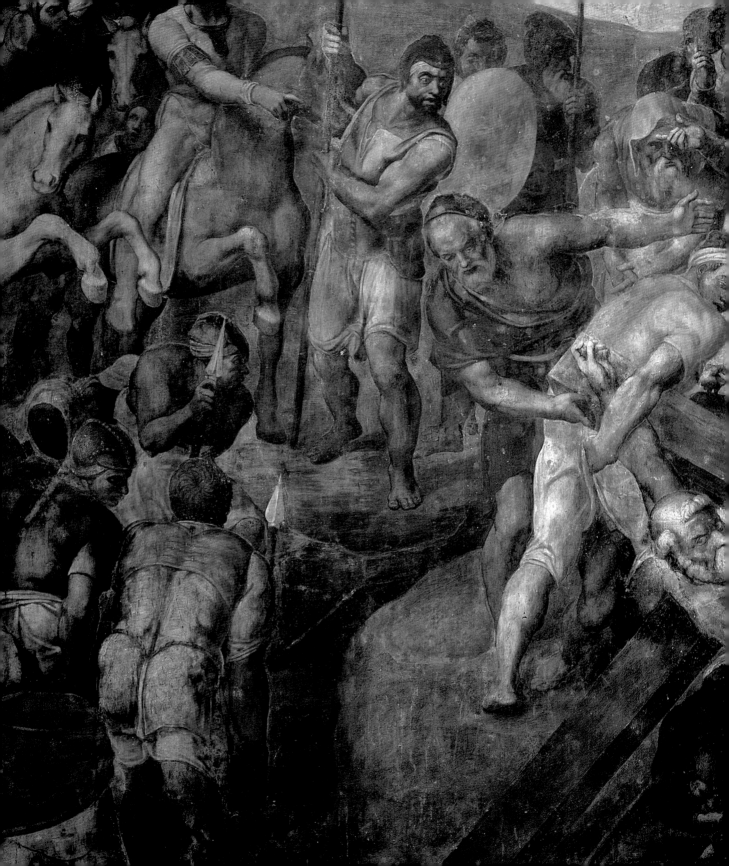

Other Vatican Frescoes

Over 20 years after the
completion of the Sistine
Chapel ceiling, Michelangelo
returned to paint *The Last
Judgement* over the altar. He was
also commissioned to paint two
frescoes for the Pauline Chapel,
depicting the Crucifixion of St
Peter and Conversion of St Paul.

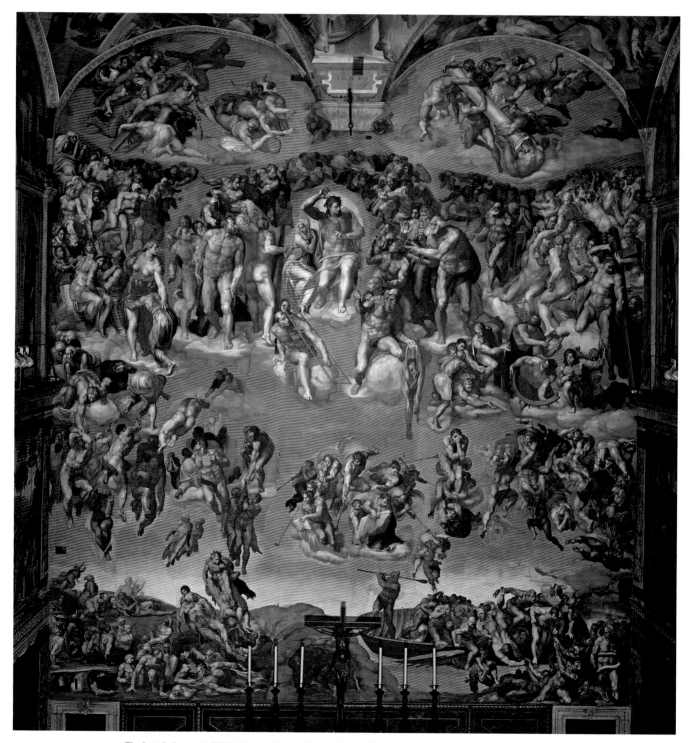

The Last Judgement, 1536–41
Fresco, 1370 x 1200 cm (539⅓ x 472¼ in)
• Vatican Museums and Galleries, Vatican City

After painting the Sistine Chapel ceiling, Michelangelo returned to complete the initial plan of the prophecy, the Second Coming and Last Judgement of Christ. In contrast to the light colourful ceiling, the dark wall above the altar (completed after the Sack of Rome) underscores the gravitas of the subject.

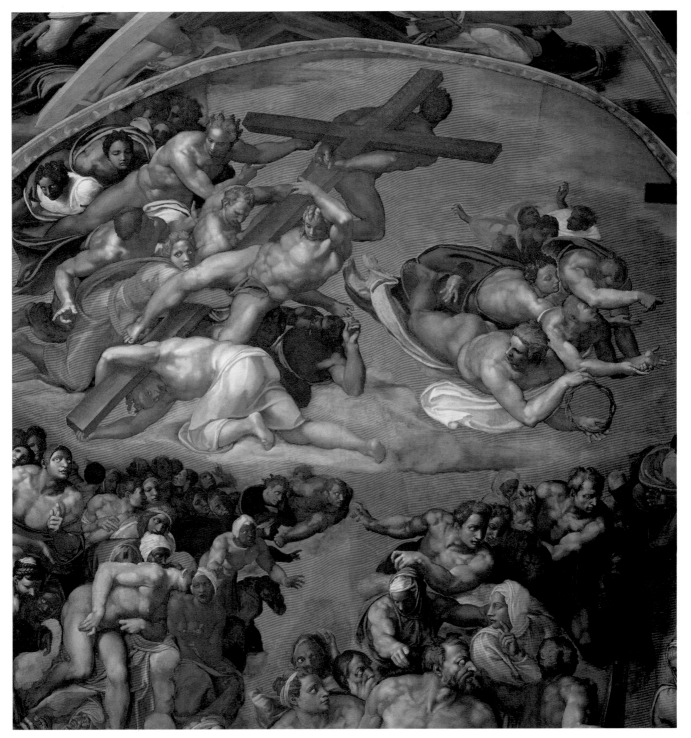

**The Instruments of Christ's Passion (left),
detail from The Last Judgement, 1536–41**
Fresco • Vatican Museums and Galleries, Vatican City

Pope Paul III gave Michelangelo much trust and faith in allowing the artist a vision that often strays from the Bible and includes figures from Antiquity and from mythology. This scene is thronging with people in a condensed drama of the Second Coming of Christ.

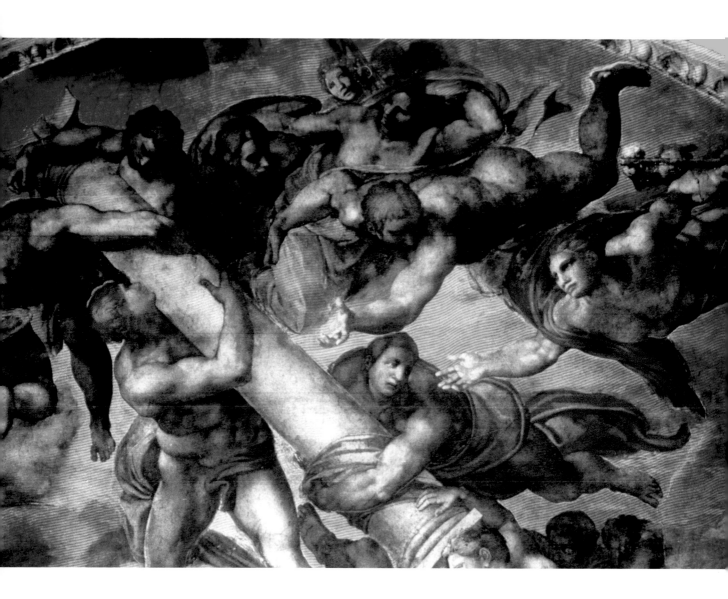

**The Instruments of Christ's Passion (right),
detail from The Last Judgement, 1536–41**
Fresco • Vatican Museums and Galleries, Vatican City

From the often static, contemplative visions of the ceiling, here Michelangelo sets Man in
motion as all participants play a role in bearing Christ in his ascendance to his throne.

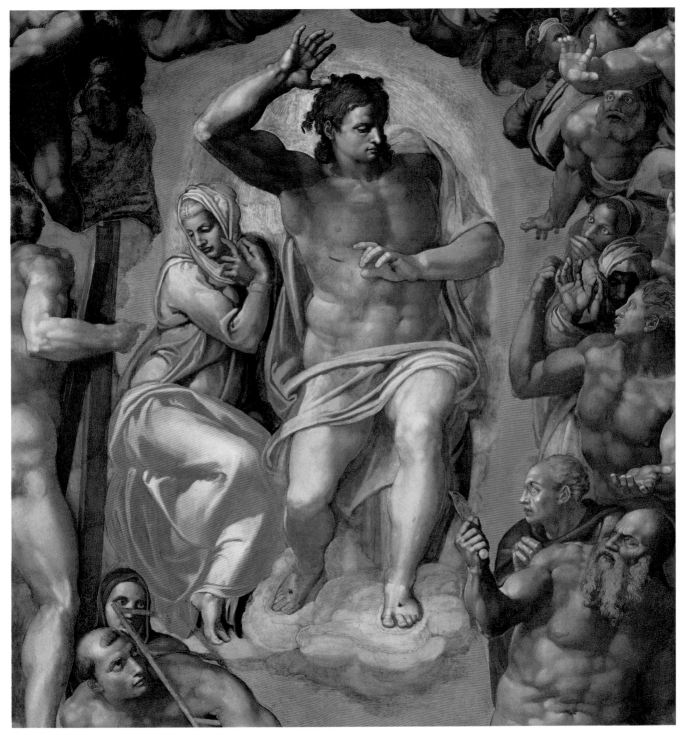

Christ, detail from The Last Judgement, 1536–41
Fresco • Vatican Museums and Galleries, Vatican City

The dark image of Christ deciding who shall be sent to Hell brings the Son of God closer
to the biblical Father Yahweh. Those attending judgement are clearly in awe of his wrath.

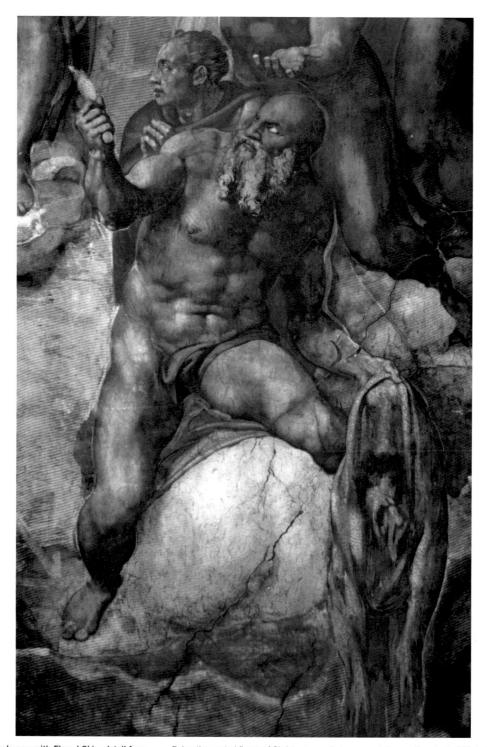

**Bartholomew with Flayed Skin, detail from
The Last Judgement, 1536–41**
Fresco • Vatican Museums and Galleries, Vatican City

Below the central figure of Christ we see what appears to be a self-portrait of Michelangelo, in the guise of Bartholomew holding the macabre remnants of his skin after having been flayed alive.

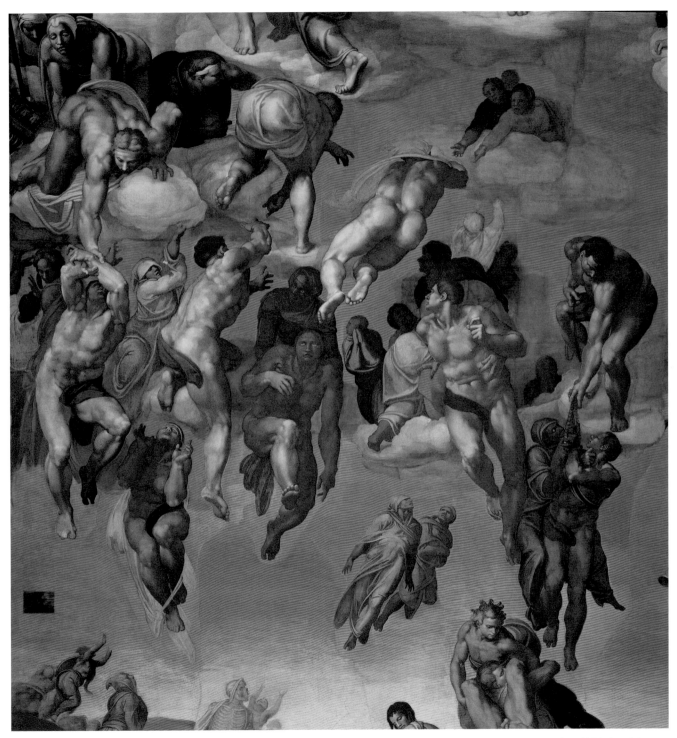

**The Righteous Drawn Up to Heaven, detail from
The Last Judgement, 1536–41**

Fresco • Vatican Museums and Galleries, Vatican City

The almost abstract treatment of the rising up to heaven displays a whole variety of Michelangelo's mastery with the human figure, now seen from all angles and perpetually in motion.

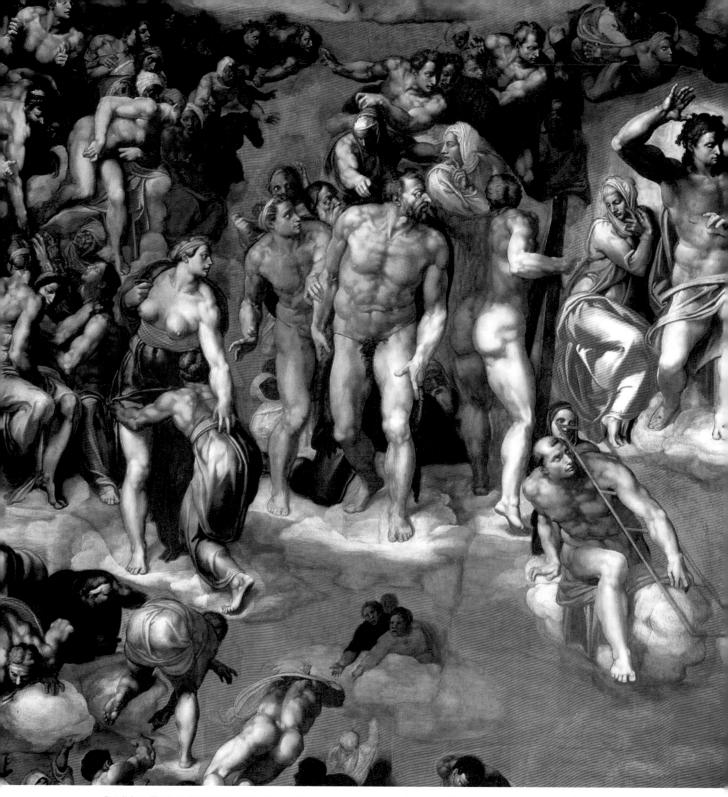

Detail from The Last Judgement, 1536–41
Fresco • Vatican Museums and Galleries, Vatican City

Michelangelo shows the wrathful side of God who has come to separate the good from the evil, and therefore begin a new cycle in the history of humanity. There appears to be no sign of compassion from Jesus either, and not one of those awaiting his or her ultimate destiny appears to be tranquil.

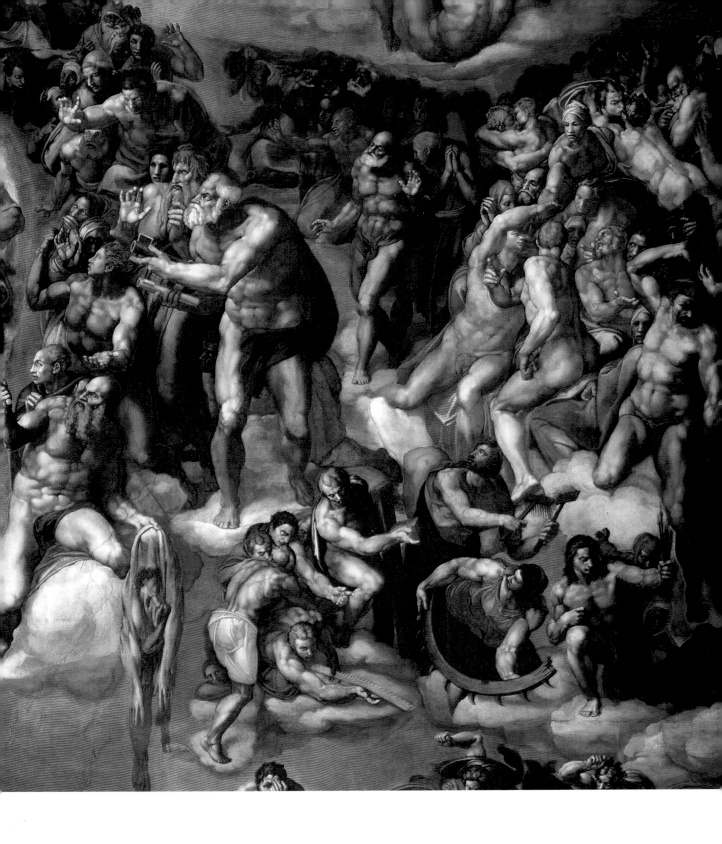

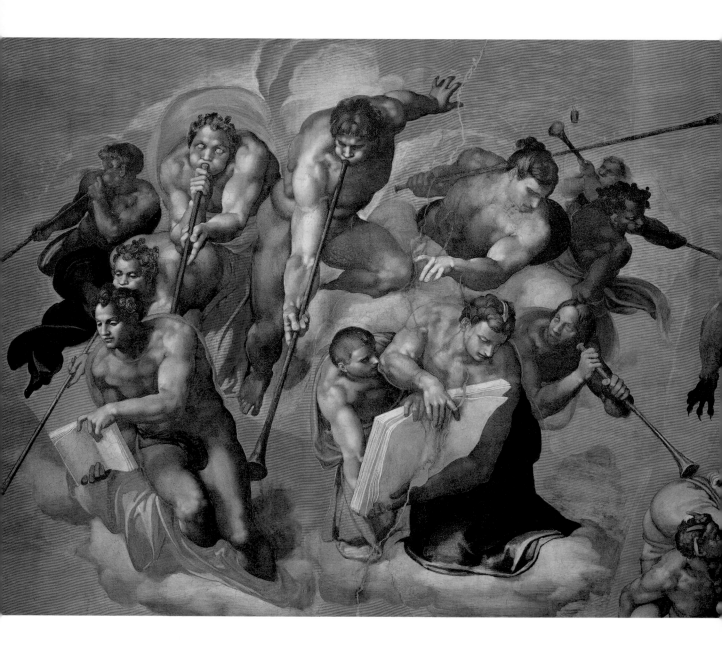

Angels Announce Doomsday, detail from
The Last Judgement, 1536–41
Fresco • Vatican Museums and Galleries, Vatican City

As the angels sound the trumpets of Doomsday it remains unclear whether music is being played, or if a loud calling for preparation is being blown to separate the good from the evil.

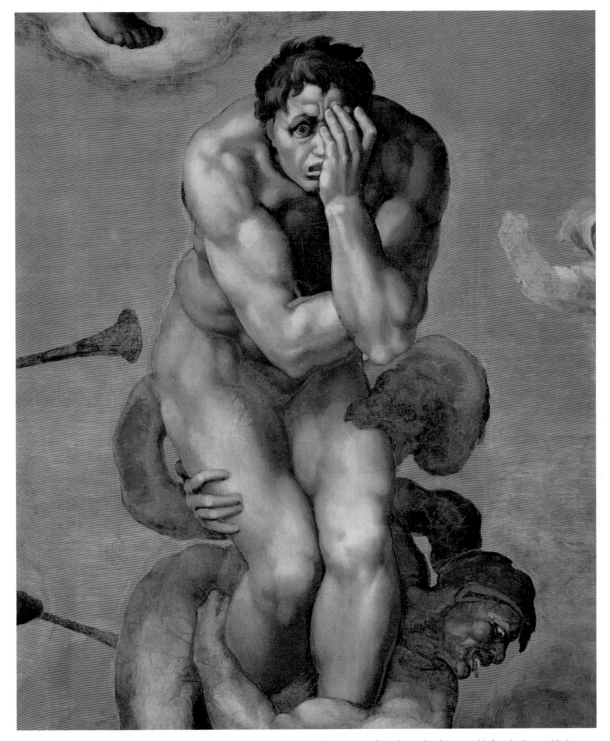

**A Damned Soul Covers His Face, detail from
The Last Judgement, 1536–41**
Fresco • Vatican Museums and Galleries, Vatican City

The horns being sounded near one of the damned as he covers his face in shame at being carried down to Hell, announce to others their fate as attention is drawn to the disbelief in the face of the judged.

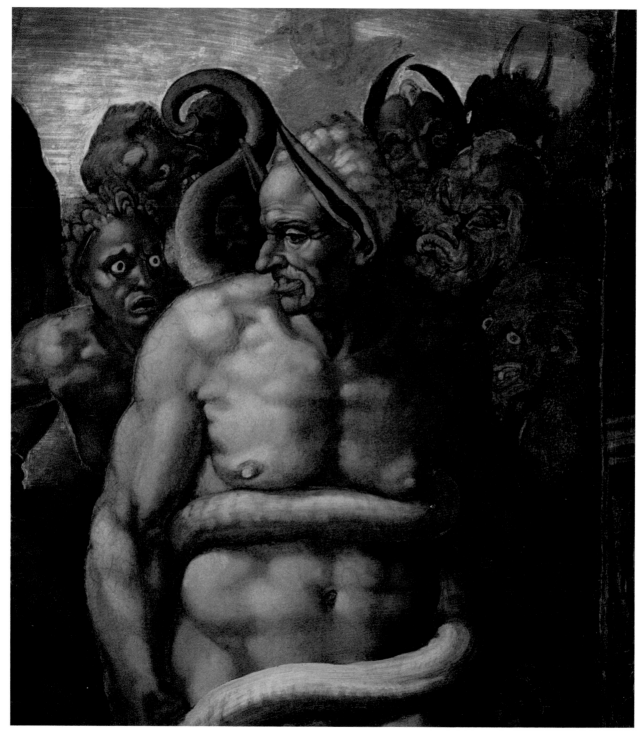

**Minos, Judge of Hell, detail from
The Last Judgement, 1536–41**
Fresco • Vatican Museums and Galleries, Vatican City

The aged Minos, girdled by the serpent of worldly knowledge and surrounded by his hungry, violent thugs who range from beastly creatures to the near dead, recalls scenes from Dante's *Inferno*.

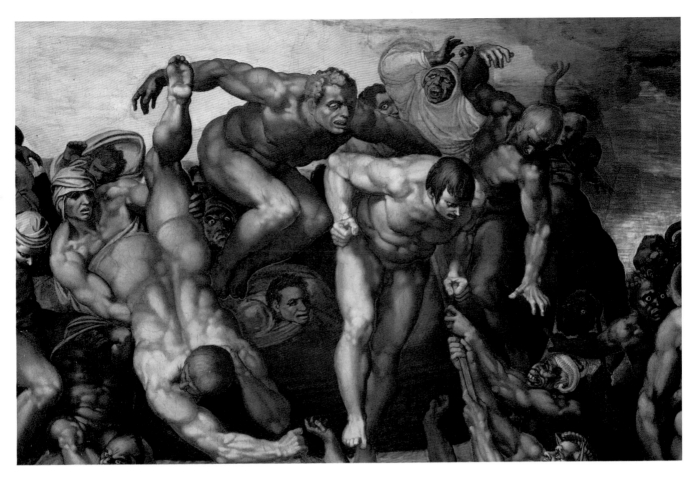

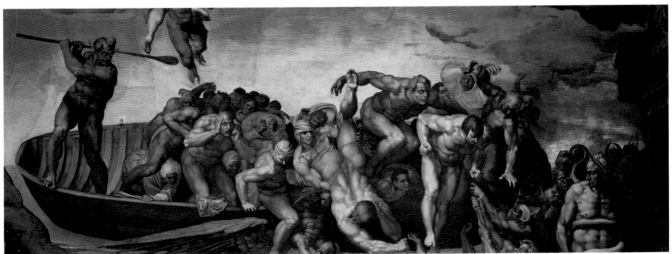

Charon, detail from The Last Judgement, 1536–41
Fresco • Vatican Museums and Galleries, Vatican City

Another Dantesque scene is shown as Charon, from Greek mythology, carries the dead across the River Styx to spend their days in suffering and hellfire.

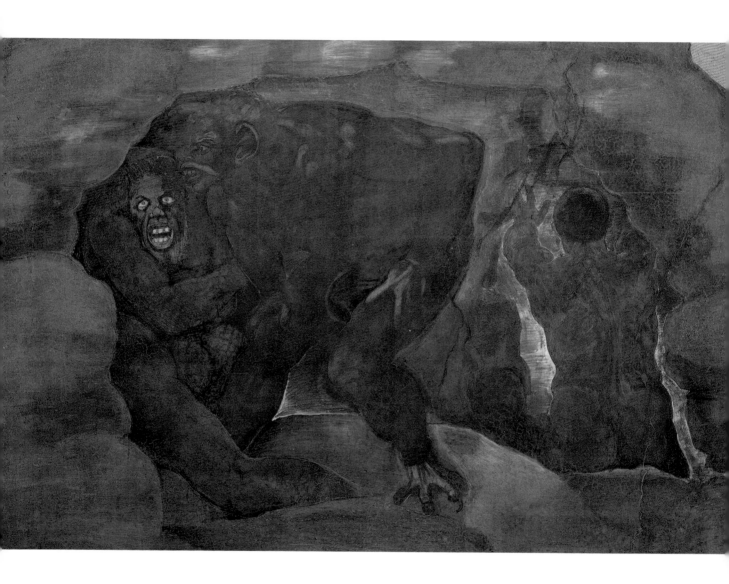

**Demons in a Cave, detail from
The Last Judgement, 1536–41**
Fresco • Vatican Museums and Galleries, Vatican City

Michelangelo's demons are sordid creatures, in general shape alone recalling the figure of man. These can be seen as the results of years in Hell, losing all sense of humanity and waiting, as it were, for new victims to frighten into submission and despair.

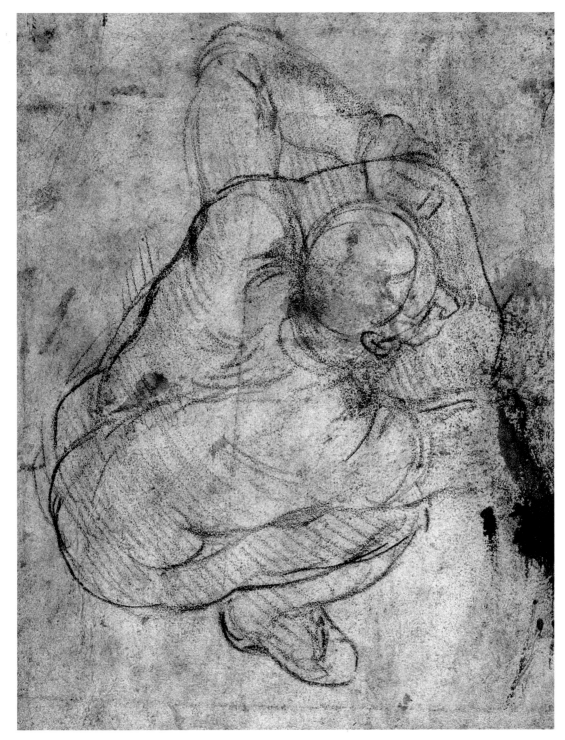

**Pulling up a resurrected soul, preparatory drawing
for The Last Judgement, c. 1536–41**

Black chalk on paper • British Museum, London

The singular crouching figure in black chalk attests to Michelangelo's attention to detail
before committing a painting to the Sistine Chapel altar wall.

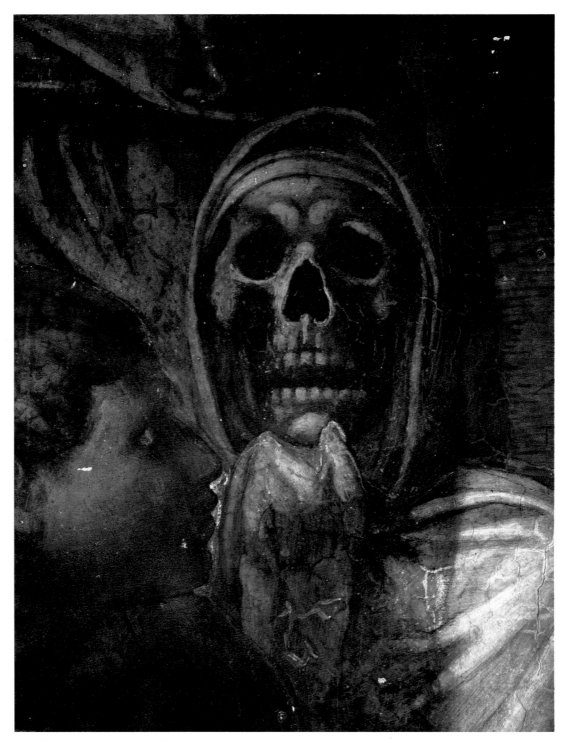

Thinking Skull, detail from The Last Judgement, 1536–41
Fresco • Vatican Museums and Galleries, Vatican City

The depiction of the man devoured by thought as represented by the black and hollow skull appears deadly serious here, as the onlooker in profile seems to discover the difference between a mind and a soul.

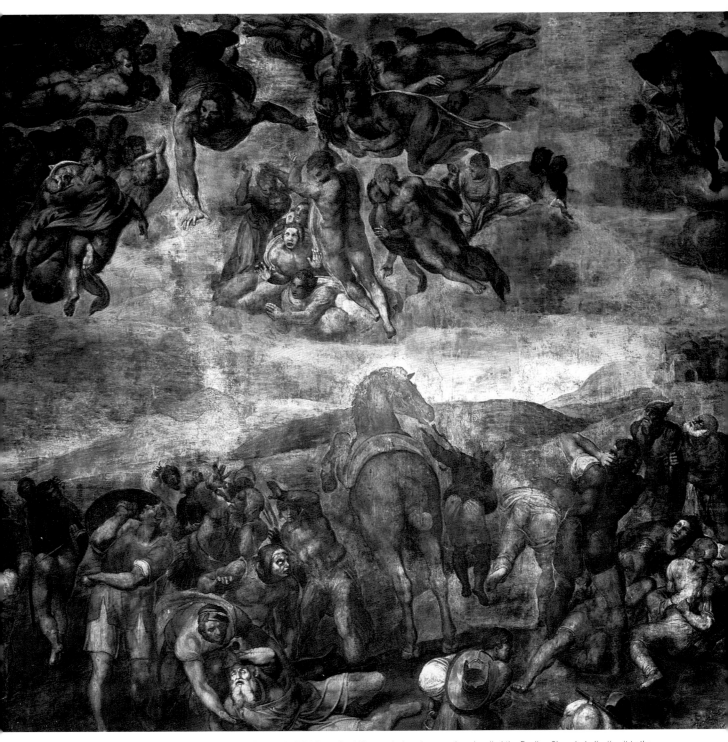

The Conversion of St Paul, *c.* **1542–45**
Fresco, 625 x 661 cm (246 x 260 in)
• Cappella Paolina, Apostolic Palace, Vatican City

In 1538 Pope Paul III commissioned a new chapel, called the Pauline Chapel, dedicating it to the Feast of the Conversion of St Paul. It is no surprise that the highly sought-after Michelangelo was chosen to decorate it with this fresco, and another depicting St Peter.

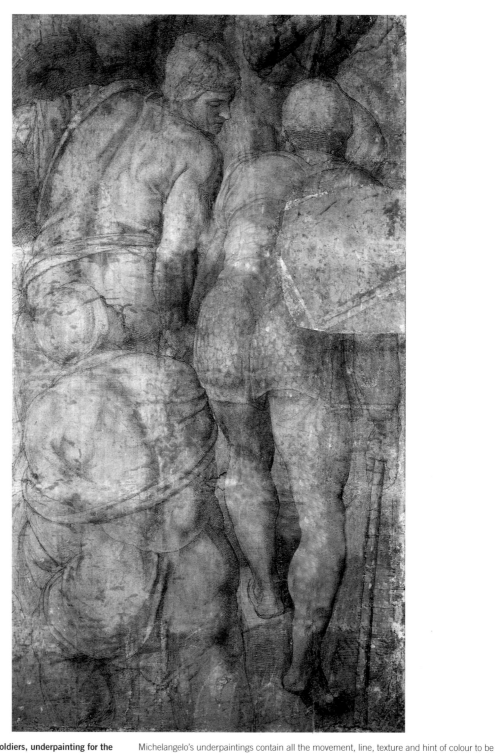

**Soldiers, underpainting for the
Crucifixion of St Peter,** *c.* **1546–50**
263 x 156 cm (103½ x 61½ in)
• Museo Nazionale di Capodimonte, Naples

Michelangelo's underpaintings contain all the movement, line, texture and hint of colour to be found in the complete work. This one appears to feature the soldiers seen in the lower left corner of the finished fresco *The Crucifixion of St Peter.*

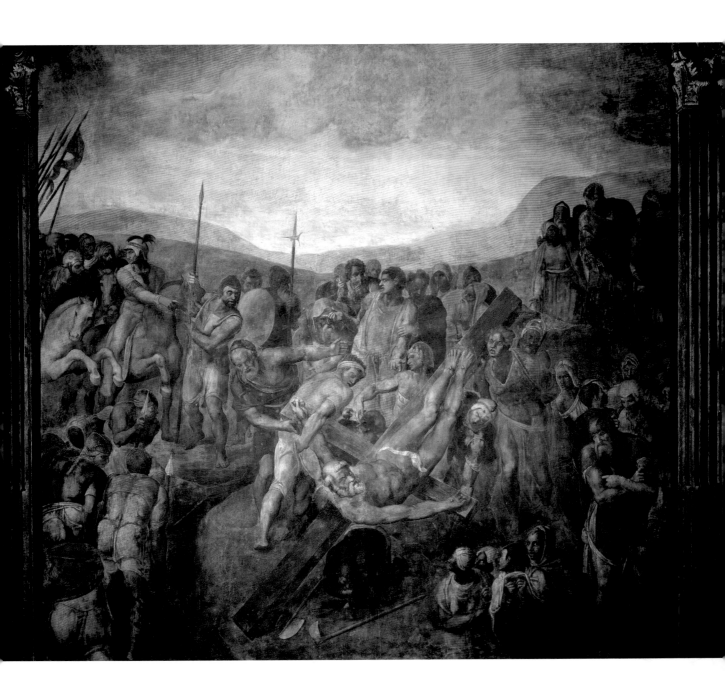

The Crucifixion of St Peter, c. 1546–50
Fresco, 625 x 662 cm (246 x 261 in)
• Cappella Paolina, Apostolic Palace, Vatican City

Here we see St Peter, who was considered the rock as head of the apostles, being martyred much like Christ. When unveiled, Michelangelo's two frescoes for the Pauline Chapel were not met with the same enthusiasm that had greeted his earlier Sistine works.

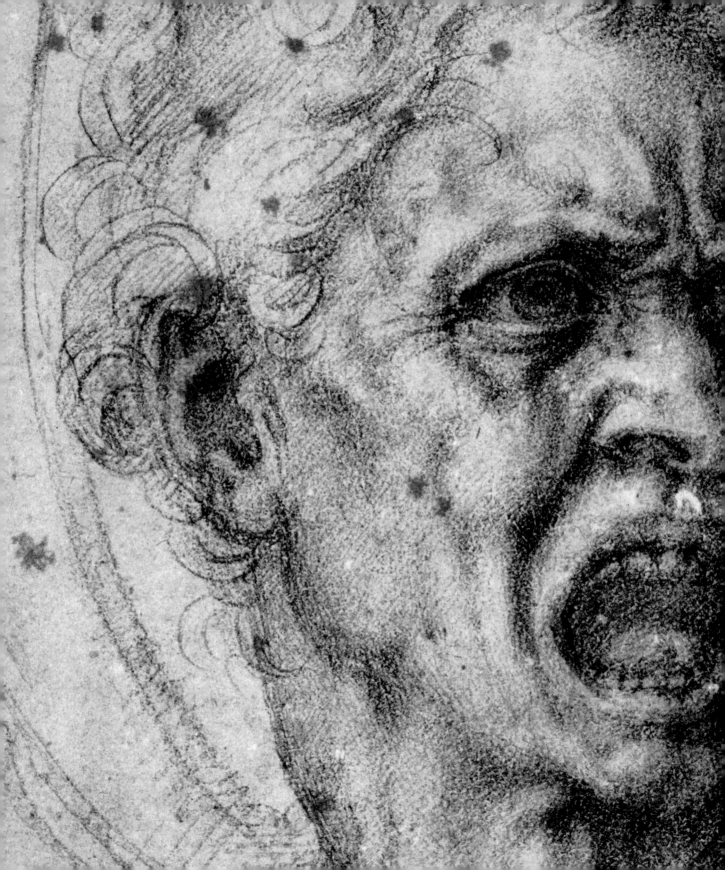

Paintings & Drawings

Although best-known for his painted frescoes, Michelangelo also painted some smaller scale artworks. His sketches and drawings often show his interest in anatomical detail and posture, although Michelangelo was known for discarding or destroying all that he considered imperfect, so very few studies remain.

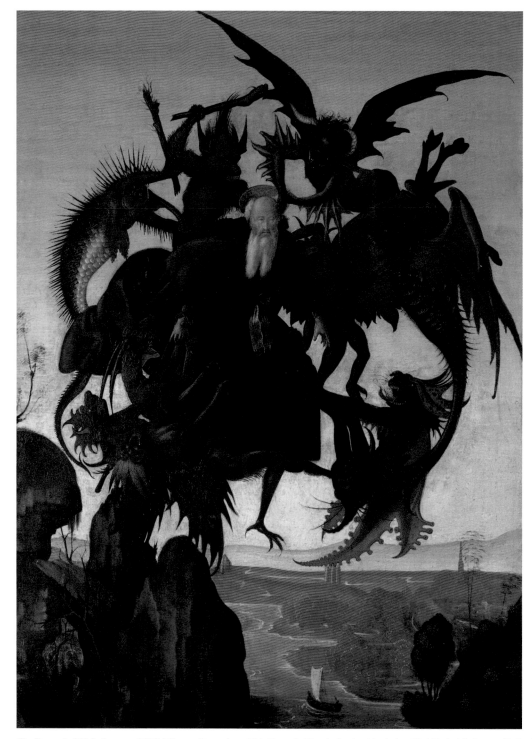

The Torment of St Anthony, *c.* 1487–88
Oil and tempera on panel, 47 x 35 cm (18½ x 13¼ in)
• Kimbell Art Museum, Forth Worth

So good was St Anthony that the devil set out to destroy his faith, but Anthony, with the Lord on his side, would not be swayed. This oil and tempera on panel is believed to be Michelangelo's first painting – inspired by an early Renaissance engraving.

Madonna and Child with St John (unfinished), *c.* **1495**
Tempera on panel, 104.5 x 77 cm (41 x 30⅓ in)
• National Gallery, London

This early, unfinished tempera depicts the doubtful story that St John the Baptist met the Virgin Mary and her Child on their flight from Egypt. One can see the influence of softer feminine beauty in contrast to Michelangelo's later focus on strong musculature and movement.

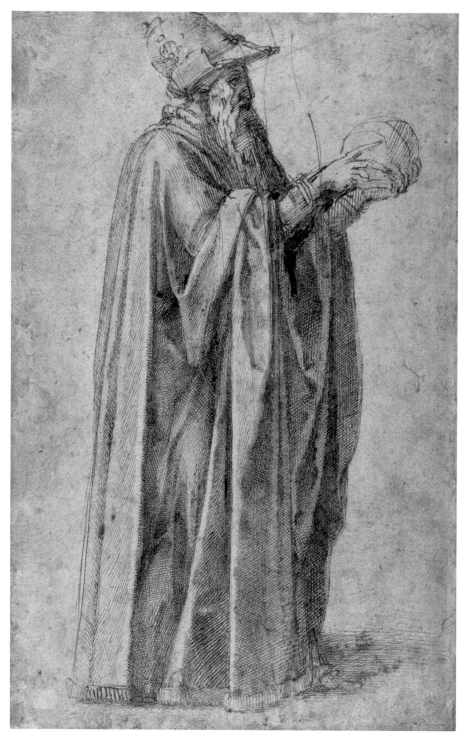

Philosopher, *c.* 1495–1500
Pen and brown ink on paper, 33.1 x 21.5 cm (13 x 8½ in)
• British Museum, London

This early piece shows a quizzical yet calm philosopher contemplating the object that holds the most sway over the concerns of the Christian philosopher, now as then: the skull as death, devoid of thought but proof of a once living soul.

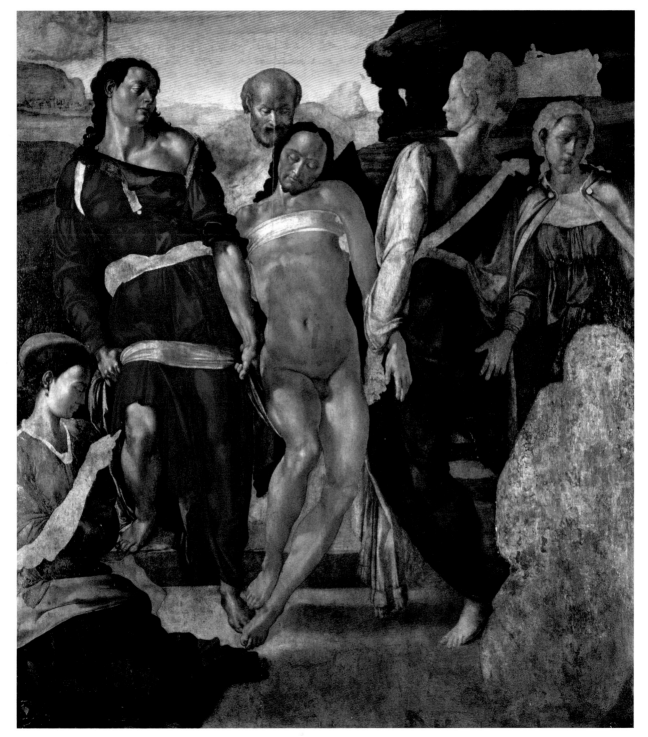

The Entombment (unfinished), *c.* **1500–01**
Tempera on panel, 162 cm x 150 cm (64 x 59 in)
• National Gallery, London

No one knows who exactly accompanies Christ from his cross to his tomb. It appears the Virgin is still merely an outline in the bottom right corner. What is striking is the calm acceptance of a prophecy fulfilled.

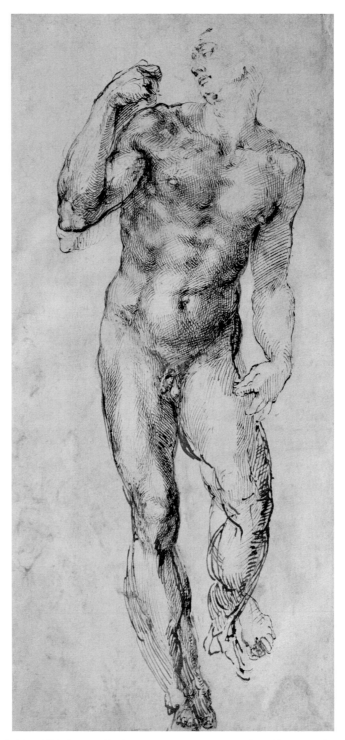

Sketch of David with his Sling, 1503–04
Pen and ink on paper • Louvre, Paris

Most likely drawn during the carving of *David*, Michelangelo has his victor's gaze inspecting his weapon, whereas in the sculpture his eyes are on Goliath. While in the sketch the sling seems crucial to David; in the sculpture, by David's gaze alone we realize that Goliath will fall in defeat.

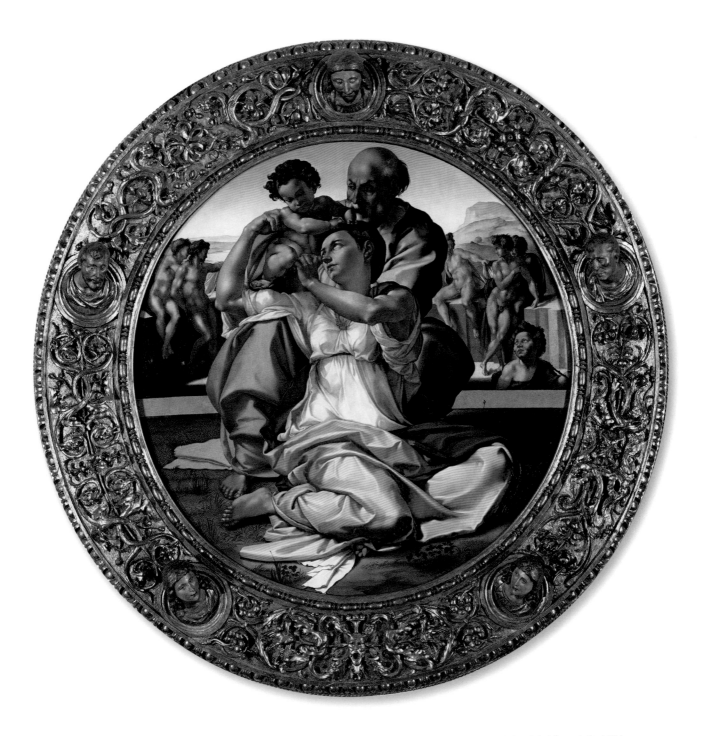

Doni Tondo, 1504–05
Oil on panel, D: 120 cm (47½ in) • Galleria degli Uffizi, Florence

Sometimes known as *The Holy Family*, this artwork is still in its original frame in the Uffizi Gallery and is the sole panel painting clearly from the hand of Michelangelo in existence.

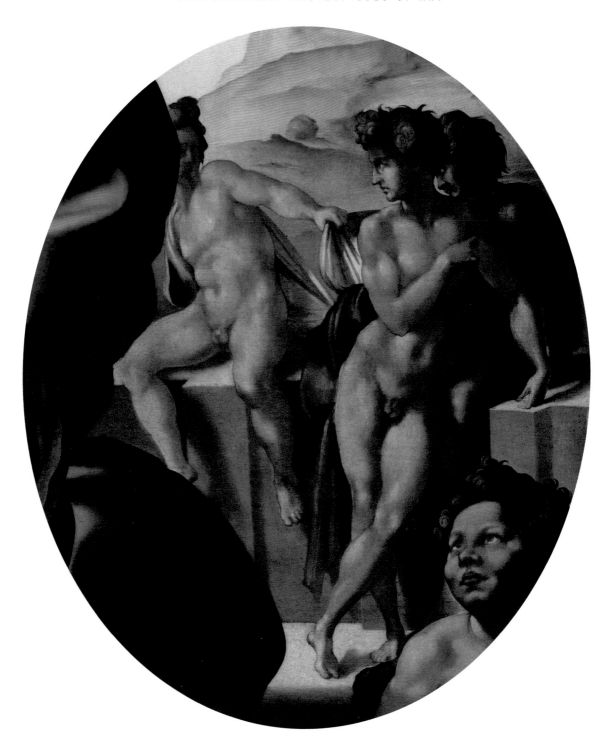

**John the Baptist as a Child with Ignudi,
detail of the Doni Tondo, 1504–05**
Oil on panel • Galleria degli Uffizi, Florence

John the Baptist is depicted as a child with Joseph, Jesus and Mary with *ignudi* in the background. Probably painted right before the Sistine Chapel, it is said that this is Michelangelo's only painting without an assistant.

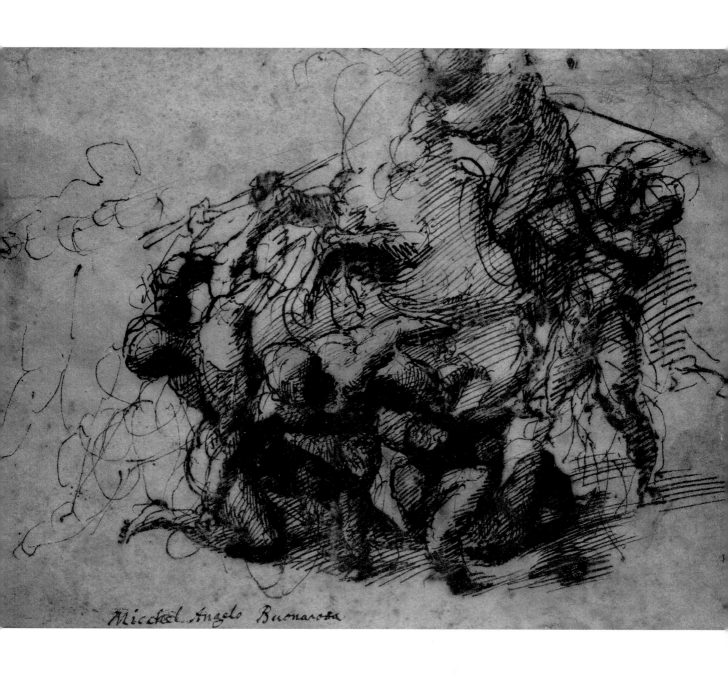

Fight Study for the Cascina Battle, 1504
Pen and ink on paper, 17.9 x 25.1 cm (7 x 10 in)
• Ashmolean Museum, Oxford

While the painting itself is presumed lost, this study depicts the fourteenth-century battle between the forces of Pisa and Florence; the latter of which, after a recent defeat, conquers its archrival and begins its reign in the Early Renaissance.

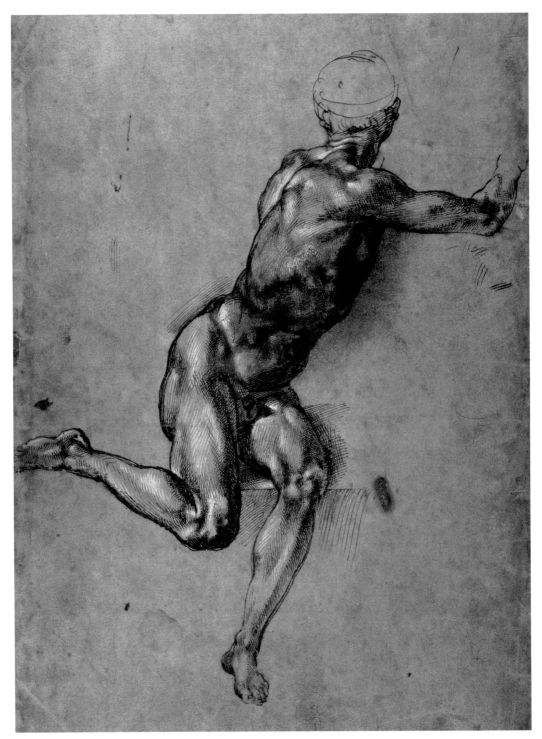

A Seated Male Nude Twisting Around, study for the Battle of Cascina, c. 1505
Pen and ink with wash on paper, 23.5 x 35.6 cm (9¼ x 14 in) • British Museum, London

Michelangelo's characteristic nude with twisted torso to display the muscles of the hips and ribs shows hints of his recent anatomical studies (knees, ankles, elbows) that will later find full body in the finished figure.

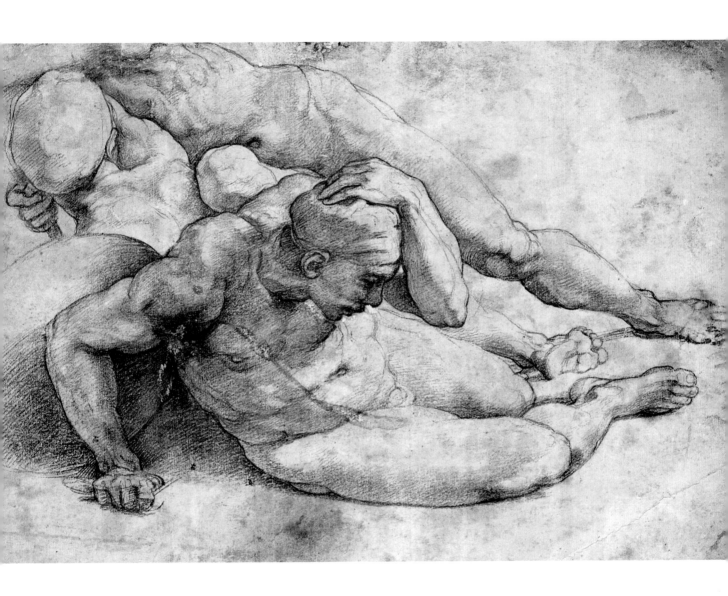

Study of Three Male Figures (after Raphael)
• Private Collection

Raphael, largely considered one of the greatest draughtsman of all times, with Leonardo da Vinci, both contemporaries of Michelangelo, believed – unlike da Vinci – that Michelangelo was as skilled at drawing as he was at sculpting.

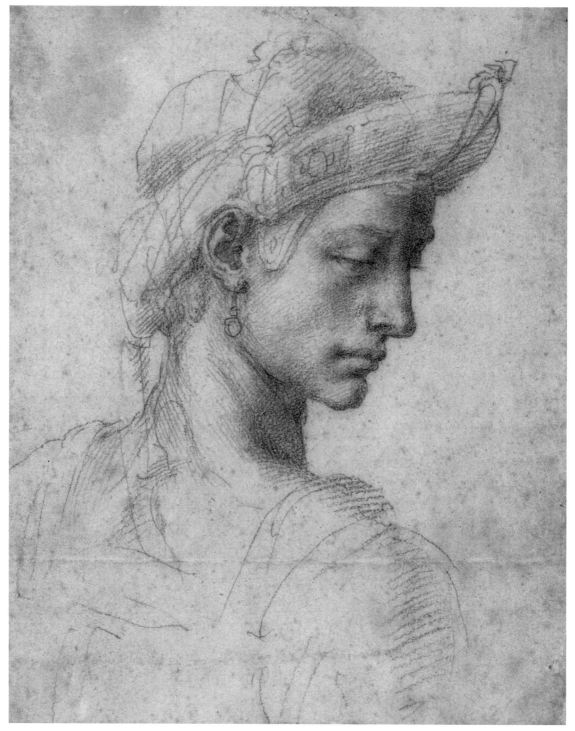

Ideal Head, 1518–20
Red chalk on paper, 20.5 x 16.5 cm (8 x 6½ in)
• Ashmolean Museum, Oxford

This 'ideal head', perhaps because of its Florentine features, is finer and thinner than many of Michelangelo's figures, in contrast both to his older men and to his youthful *ignudi*.

Madonna and Child, *c.* 1525
Pencil and red chalk, 40 x 54 cm (15½ x 21⅓ in)
• Louvre, Paris

Jesus appears to be suckling the Virgin Mary while she looks away expressionless in regards to the boy, perhaps concerned by something that is being said or done near them.

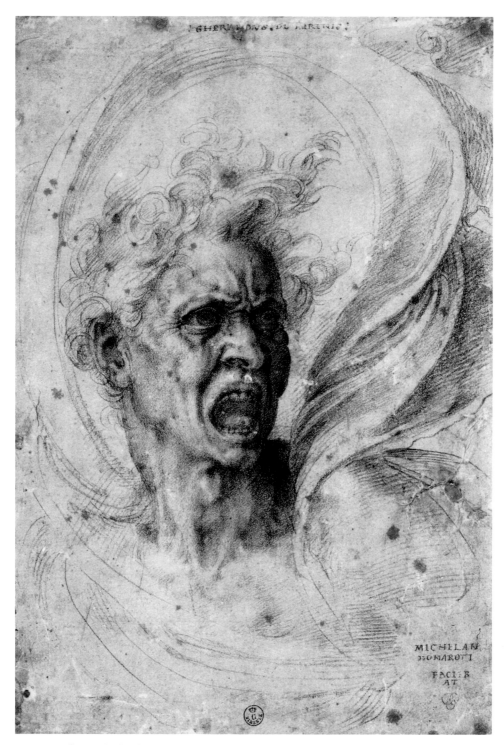

Damned Soul, *c.* 1525
Indian ink on paper, 25.1 x 35.7 cm (9⅞ x 14 in)
• Galleria degli Uffizi, Florence

Out of context, this could simply be the cry of a man for a study or, more symbolically, a shout representing human frustration. But the title, *Damned Soul,* leads one to believe that Michelangelo had given much thought to a man's reaction to the Last Judgement, even before painting a representation of it.

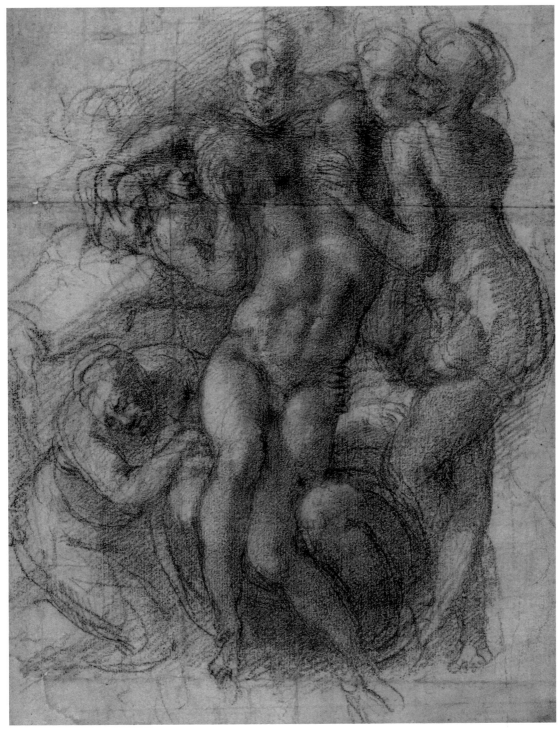

Lamentation, _c._ 1530
Red chalk, partly over a preliminary drawing in black chalk,
32 x 24.9 cm (12½ x 9⅛ in) • Albertina, Vienna

Christ's body appears subject to the examination of the painter and it is being upheld, in preparation for transportation to his tomb. Here, the grouping of Christ's intimates and his crucified body seem to be as one.

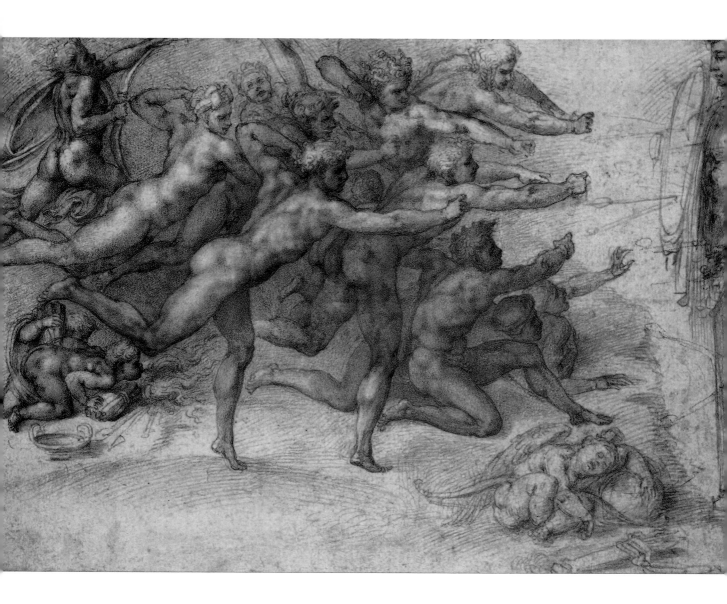

Archers Shooting at a Herm, *c.* 1530
Red chalk on paper, 21.9 x 32.3 cm (8⅝ x 12½ in)
• Royal Collection Trust

A herm is a stone pillar, usually with the carved head of Hermes on top. For Michelangelo it represents the sculptor's bow that was used to drill holes in marble. On a drawing of *David*, he wrote 'David with his sling / and I with my bow / Michelangelo'.

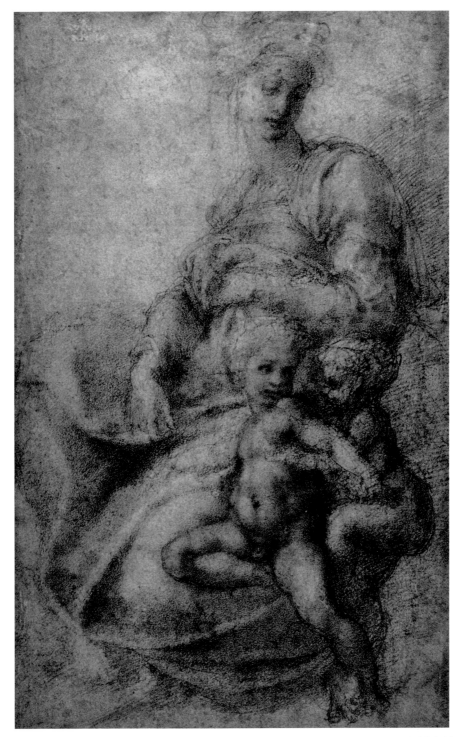

The Virgin and Child with the Infant Baptist, *c.* 1530
Black chalk on paper, 31.4 x 20 cm (12⅓ x 7⅞ in)
• British Museum, London

Here is one of Michelangelo's especially playful scenes between the Virgin Mary, Jesus and John the Baptist. While the Virgin maintains a certain distant regard, the two little boys are allowed an uncharacteristic freedom to play.

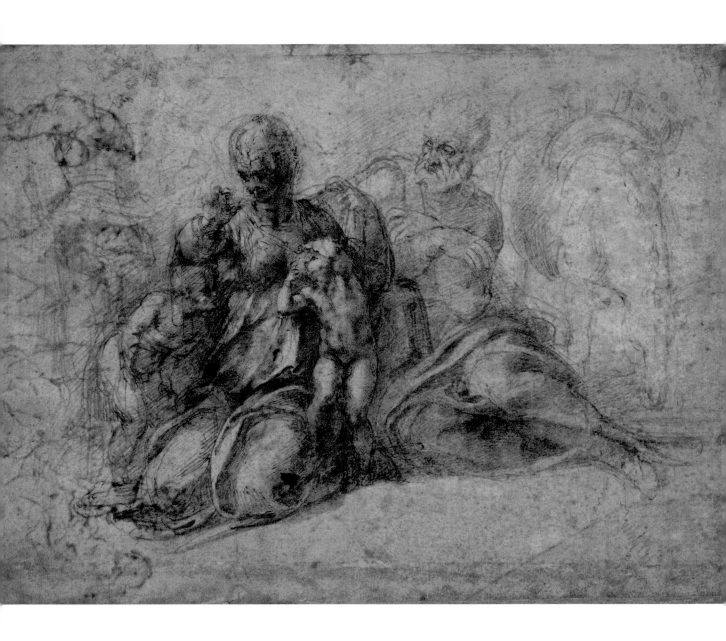

The Holy Family, *c.* 1530
Black and red chalk with pen and brown ink over stylus,
27.9 x 39.4 cm (11 x 15½ in) • J. Paul Getty Museum, Los Angeles

The significance of this late drawing appears to be in the importance of having John the Baptist next to the Virgin Mary as she is breastfeeding the baby Jesus.

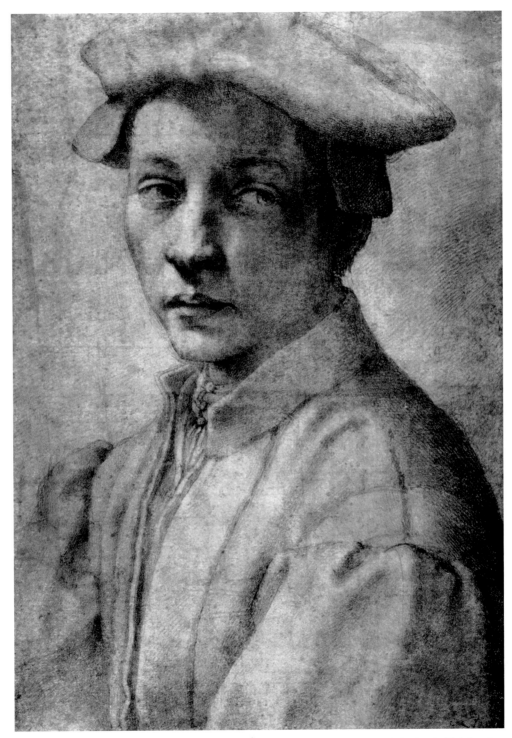

Portrait of Andrea Quaratesi, *c.* **1532**
Black chalk on paper, 41 x 29 cm (16 x 11½ in)
• British Museum, London

This is one of the rare – if not only – remaining portrait drawings by Michelangelo, who was known for destroying individual drawings he did not consider to be perfect.

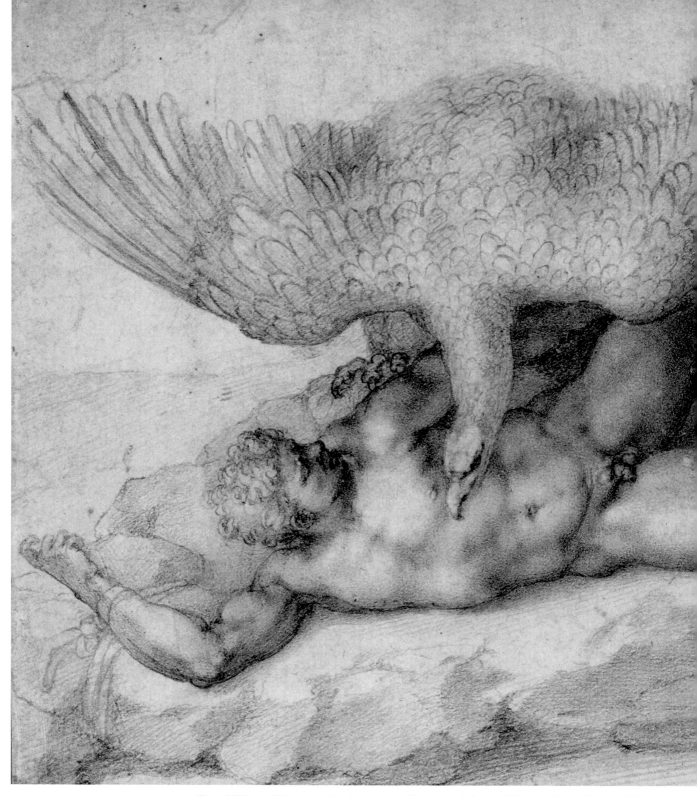

Tityus, 1532
Pencil on paper, 19 x 33 cm (7½ x 13 in) • Royal Collection Trust

This drawing of a vulture devouring Tityus in a sort of no-man's land was given to Tommaso de'Cavalieri. Michelangelo often expressed the feeling that he was prisoner to the devotion of the young noble who remained his companion for over 30 years.

The Fall of Phaethon, 1533
Chalk on paper, 31.2 x 21.5 cm (12⅛ x 8½ in)
• Royal Collection Trust

Phaethon was the son of Helios, a demi-god who wanted to drive the sun-chariot. Against his father's better judgement, Phaethon was allowed to drive the chariot but it crashed and set Earth on fire, scorching the fields of Africa to desert.

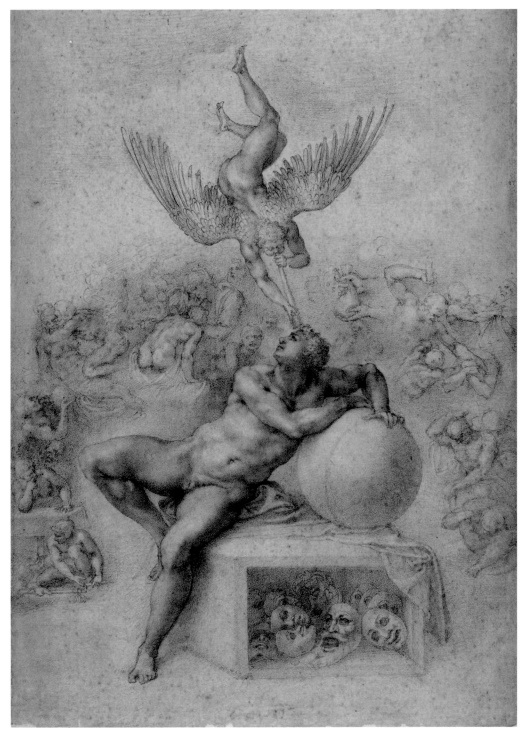

The Dream of Human Life, *c.* 1533
Graphite and paper, 39.6 x 27.9 cm (15½ x 11 in)
• The Courtauld Gallery, London

This allegorical drawing appears to represent the deadly sins behind a depiction of a male nude who has been thought to represent the mind or the soul. It has been suggested that this was one of the drawings Michelangelo made for Tommaso de'Cavalieri.

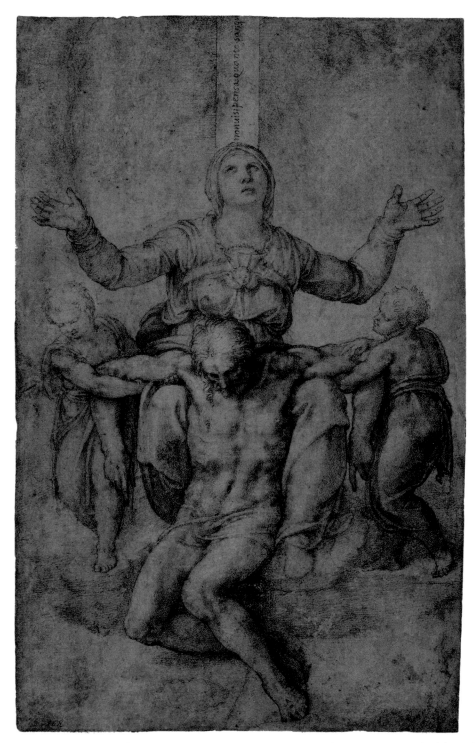

Study for the Colonna Pietà, 1538–44
Black chalk on paper, 28.9 x 18.9 cm (11½ x 7½ in)
• Isabella Stewart Gardner Museum, Boston

Vittoria Colonna was Michelangelo's pious female friend who remained close to him until her death. She was a Church reformist and fulfilled the artist's need to believe that the suffering of Christ was cause for joy and faith in God's divine nature.

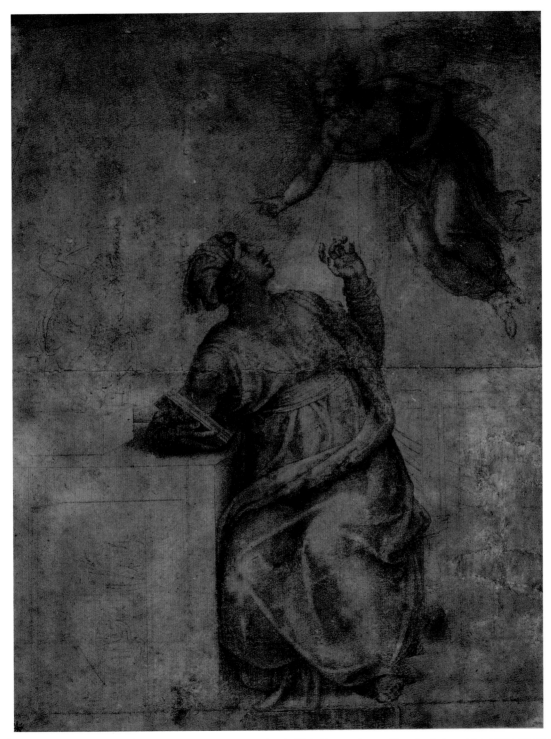

Annunciation to the Virgin, 1547–50
Black chalk, outlines indented, 30 x 38.4 cm (11⅛ x 15 in)
• The Morgan Library & Museum, New York

Taken by surprise, the Virgin Mary receives word from the Archangel Gabriel that she will conceive of Jesus Christ, the Saviour. In this portrayal of the Virgin Mary we see Michelangelo's mastery of draped clothing, shading, and transparencies.

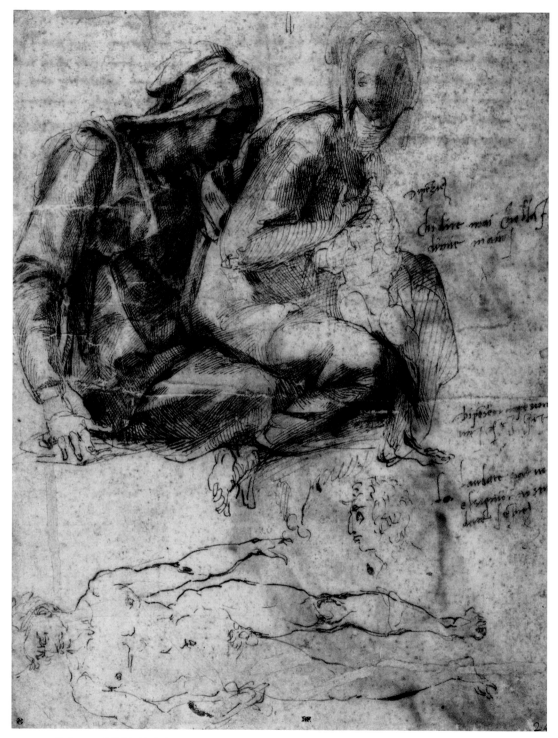

Madonna and Child with St Anne
• Private Collection

The Virgin Mary, holding a cursorily sketched Jesus, and her mother, Anne, are the study's main figures. The figure at the bottom could be a study for the Archangel Gabriel.

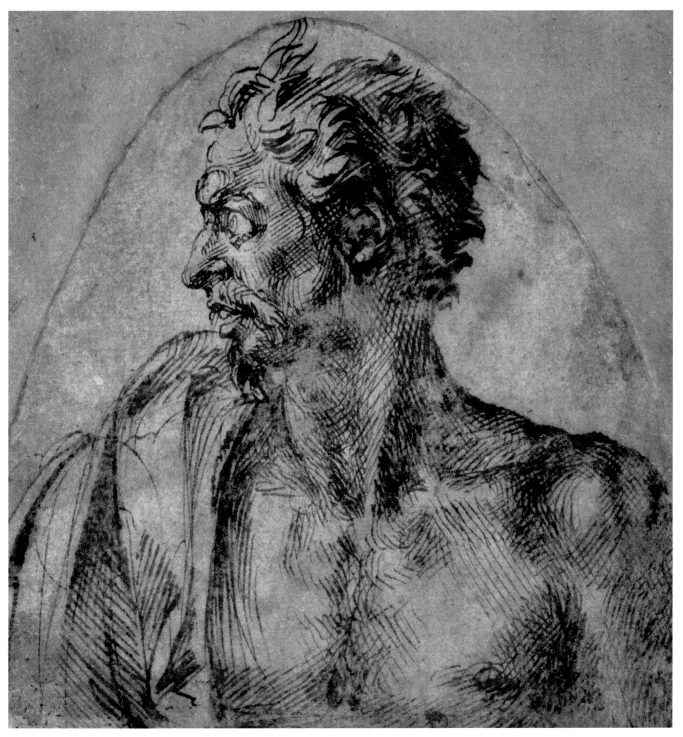

Study of Head and Shoulders
Ink on paper • British Museum, London

This drawing shows Michelangelo's intricate use of lines that would no doubt be the scaffolding for the figure's musculature were the portrait finished.

Indexes

Index of Works

Page numbers in *italics* refer to illustrations.

General Index

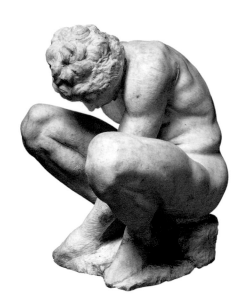

Masterpieces of Art

FLAME TREE PUBLISHING

A new series of carefully curated print and digital books covering the world's greatest art, artists and art movements.